IMAGES
of America

WILLIAM CULLEN BRYANT'S
CEDARMERE ESTATE

D1451861

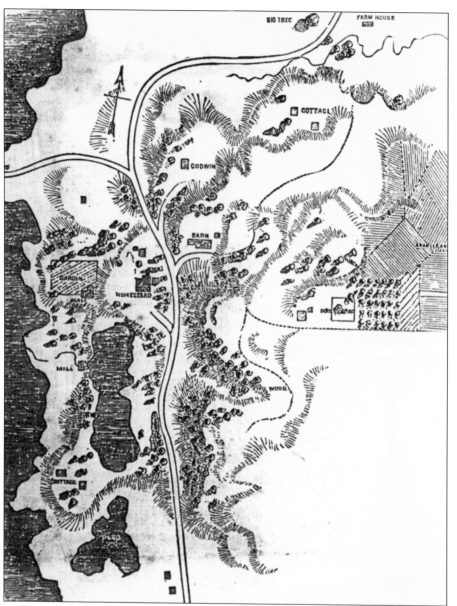

The Cedarmere estate is depicted in the July 17, 1869, *Hearth and Home* magazine, as shown here. The main house, labeled "Homestead," is above the larger pond. The mill lies along the pond's west side, and Goldenrod cottage is past the bridge at the pond's south end. Across the street (now Bryant Avenue) are Bryant's upland farm and barns. North of them are Montrose, Mudge Cottage, Sweet Briar, Boxwood, and the landmark black walnut tree. (Nassau County Photo Archives Center.)

ON THE COVER: William Cullen Bryant's great-granddaughter Elizabeth Love Godwin poles her canoe across the pond in front of Cedarmere around 1905. This photograph was probably taken by Elizabeth's sister Frances Bryant Godwin, an avid amateur photographer. Frances took many of the early-20th-century photographs used in this book. (Cedarmere Collection of the Nassau County Department of Parks, Recreation and Museums.)

IMAGES
of America

WILLIAM CULLEN BRYANT'S
CEDARMERE ESTATE

Harrison and Linda Hunt

ARCADIA
PUBLISHING

Published by Arcadia Publishing
Charleston, South Carolina

Printed in the United States of America

Library of Congress Control Number: 2015953021

For all general information, please contact Arcadia Publishing:
Telephone 843-853-2070
Fax 843-853-0044
E-mail sales@arcadiapublishing.com
For customer service and orders:
Toll-Free 1-888-313-2665

Visit us on the Internet at www.arcadiapublishing.com

*To the dedicated people who gave generously and
worked tirelessly to restore Cedarmere*

CONTENTS

Acknowledgments

We would like to express our appreciation to the following individuals and organizations for their assistance with this book:

Arcadia Publishing acquisitions editor Gillian Nicol, who proposed the project, and project manager Matthew Todd, who worked with us throughout production.

The Friends of Cedarmere, who suggested we write this book—particularly Eugene Neeley and Paul Baserman, who recommended us, and Thomas Powell, who gave us access to Cedarmere on several occasions.

The Nassau County Department of Parks, Recreation and Museums and deputy commissioner Eileen Krieb for providing free access to materials in the Cedarmere collections and in the department's Photo Archives Center; Gary Haglich, who cheerfully spent days allowing us to copy materials in the county's collections; and Iris Levin and Toni Liberty, who gave us tremendous help at the Nassau County Photo Archives.

Carol Clarke, Myrna Sloam, and Rosa Mejia of the Local History Collection at the Bryant Library; Anne Tinder and Jennifer Lister of the Roslyn Landmark Society; Valerie Onorato, Nicole Rhodes, and Stephen Fellman of the Village of Roslyn Harbor; Nicole LaPinta of the Trustees of Reservations Archives and Research Center; Rebecca Smith of the Historic New Orleans Collection; Town of North Hempstead historian Howard Kroplick; Erik Huber of the Long Island Division, Queens Borough Public Library; Vincent Ciminera, manager of the Roslyn branch of the Roslyn Savings Bank; Joe Scotchie of the *Roslyn News*; Wayne Hammond, director of the Chapin Library, Williams College; and Gschwind family members Eleanore Tooker and Bradford Tooker, for their invaluable help.

Images in this volume from the Cedarmere Collection of the Nassau County Department of Parks, Recreation and Museums are noted (NC), those from the Nassau County Photo Archives Center (NCPA), and those from the authors' collection (AC). The sources for all other illustrations are indicated in the captions.

INTRODUCTION

"Congratulate me! . . . I have made a bargain for about 40 acres of solid earth at Hempstead Harbor, on the north side of Long Island." With these words, William Cullen Bryant enthusiastically announced to his brother John that he had purchased the estate that he later christened Cedarmere. From 1843 until his death in 1878, Bryant delighted in the serene beauty of the setting. In the years that followed, Cedarmere was cared for by three generations of the family. This site, which has been described as "a little gem," remains one of the most picturesque places on Long Island's North Shore.

When William Cullen Bryant (1794–1878) purchased Cedarmere, the 49-year-old was already regarded as America's senior poet. A native of Cummington, Massachusetts, Bryant had earned acclaim as the nation's first major poet while still a young man with the publication of "Thanatopsis" in 1817 and "To a Waterfowl" in 1818. The latter work is still regarded by many scholars as the finest short poem in the English language.

Bryant relocated to New York in 1825 to edit a literary journal. While the magazine was not a success, the young poet made a good impression, and when the *New York Evening Post* needed an acting editor the following year, he was offered the job. Bryant was soon made editor-in-chief and part owner of the newspaper, a position he kept for the remainder of his life. After he bought Cedarmere, he commuted to the city by the boats that ran regularly from the public dock just north of the house. Bryant would usually spend long weekends at Cedarmere from spring through December, staying in the city midweek and in winter. He eventually purchased a brownstone on West Sixteenth Street for this purpose.

Bryant used the editorial pages of the *New York Evening Post* to champion many causes, including better treatment for workingmen and immigrants and the rights to unionize and strike. He was an outspoken opponent of slavery for years and was one of Abraham Lincoln's earliest supporters in New York, introducing the would-be presidential candidate at his famous Cooper Union speech in February 1860. Bryant was an early proponent of the Hudson River School, the catalyst behind the creation of New York's Central Park, and a founder of the Metropolitan Museum of Art and the National Academy of Design. In recognition of his many accomplishments, Bryant Park in Manhattan was named in his honor. Locally, when Nassau County broke off from the rest of Queens in 1898, it was almost named Bryant County after its most famous former resident. Although little remembered today, William Cullen Bryant was nationally significant as a poet, newspaper editor, and civic reformer. Of all the museums in Nassau County, Cedarmere is second only to Sagamore Hill in national importance.

In addition to making Bryant one of New York's most well-known citizens, the *Evening Post* also made him a wealthy man. By 1870, he owned his Manhattan brownstone, a summer home and two farms in Cummington, Massachusetts, acreage in Illinois, and his 170-acre Cedarmere estate in Roslyn. Cedarmere was one of the first of Long Island's fabled Gold Coast estates. Unlike most of them, which had their buildings and landscapes carefully designed in advance,

Cedarmere was more manorial; Bryant developed his estate for the most part by purchasing existing farms and buildings. He eventually owned thirteen houses, two mills and a number of barns and other outbuildings at Cedarmere, renting many of them and a portion of his farmland to tenants. Of these structures, only two, the Jerusha Dewey Cottage and the Gothic Revival Mill, were constructed to complement each other.

Bryant loved nature and lavished great attention on Cedarmere's landscaping. He delighted in planting ornamental trees on the property and had extensive pear, apple, plum, and cherry orchards, as well as a grapery. The poet developed trails through the woods, carefully trimming trees to open views of the harbor. Along with his wife, he maintained a large flower garden supported by a greenhouse and forcing shed. Bryant's boxwood-edged flower garden has been re-created at Cedarmere, and a number of trees have been planted anew, including an orchard of heirloom pear trees north of the house.

Bryant lived at Cedarmere with his beloved wife, Frances Fairchild Bryant (1797–1866), and his younger daughter, Julia Sands Bryant (1831–1907), who never married; his elder daughter, Frances (1822–1893), lived elsewhere on the estate with her husband, Parke Godwin (1816–1904), and their eight children. At the poet's death, the Cedarmere estate was divided between his two daughters. Julia received the main house and the southern half of the estate, which she subsequently sold to her sister's youngest son, Harold Godwin.

Harold Godwin (1858–1931) was an urbane man who had been educated in Geneva, Switzerland, and at Princeton University before studying art criticism in Paris, France. Godwin was also a talented watercolor artist and sculptor who studied portrait sculpture under Augustus Saint-Gaudens. In addition to managing the family's real estate holdings, Godwin wrote art-related columns for the *New York Evening Post* and other newspapers.

Godwin was destined to play a major role in the history of Cedarmere. When he was renting the house to a tenant in 1902, it suffered a serious fire. Godwin quickly decided to rebuild it, retaining its basic appearance and floor plan in appreciation for its historical importance. In so doing, Godwin became the first preservationist in the historically minded community of Roslyn. He went on to re-create the village's 18th-century paper mill in what is now Gerry Park in 1915, and to restore the landmark gristmill on Northern Boulevard in 1916–1917. Although his method would not meet approval today—he altered Cedarmere's exterior construction and placed concrete cast to look like clapboards on the gristmill—he was sincere in his efforts, which did succeed in preserving these structures for future generations. Recognizing Cedarmere's importance, his daughter Elizabeth Love Godwin (1891–1975) left it to Nassau County to preserve as a park, museum, and memorial to William Cullen Bryant. The site opened to the public in honor of Bryant's bicentennial on November 3, 1994.

In Bryant's time, the name "Cedarmere" would have applied to both the main house and entire estate. In this book, Cedarmere refers to the main house and the surrounding seven acres that comprise the present-day site. Its historically significant mill and gardens are addressed in chapters of their own. The rest of Bryant's property is covered in the chapters about the northern and southern estates.

One

Cedarmere from 1787 to 1859

The oldest sections of present-day Cedarmere were constructed in 1787 by Richard Kirk, a Quaker farmer and businessman who had been raised on the site. Kirk's family home stood west of Cedarmere, approximately where the flower garden is today. This building had been constructed by a member of the Pine family in the late 1600s or early 1700s, making it one of the earliest houses in Roslyn Harbor. By the close of the American Revolution, it was falling into disrepair, so Kirk opted to build a new house next to it. "Kirk . . . appears to have loved his comfort and certainly built one of the most livable and substantial houses," Harold Godwin wrote in 1903. "The old frame work of oak with its mortised joints was built to stay. Timbers four times the size considered necessary today were hewn and shaped on the land." The interior of the house, judging by the original woodwork in the parlor, was a good example of local Quaker aesthetic: well-built and stylish without excessive ornamentation.

In 1821, Kirk's heirs sold the house and the adjoining 40 acres of land to Obadiah Jackson, who in turn sold it to his son-in-law William Hicks in 1834. Later that year, New York attorney Joseph Moulton and his wife stopped at the house, and they were so enamored with it that they bought it. Moulton soon developed an idea for a planned community called Montrose on the property east of Cedarmere, approximately where the Nassau County Museum of Art is now. Unfortunately for him, the nationwide Panic of 1837 caused the project to fail after he had sold only two lots. Moulton fell into debt and, within five years, was forced to put his house and land on the market.

Moulton's advertisement was seen by William Cullen Bryant, who purchased the house and property in 1843. He originally called the place Springbank because of the many springs of water on the site, but soon gave it the more poetic name Cedarmere after the cedar trees that ringed the mere.

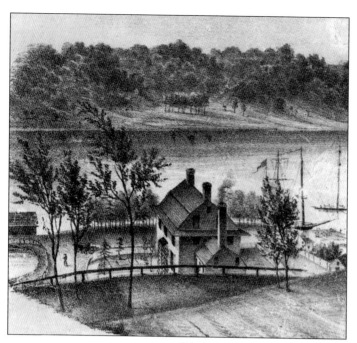

This 1847 print by Bufford features Cedarmere as it originally appeared. It was a two-and-a-half-story house with a wood-shingled roof and overhang that caused Leonice Moulton to dub it "the brown hat." The kitchen dependency, as such wings were referred to, is attached to the house in the foreground. The original mill can be seen to the left, beyond the pond. (AC.)

In 1843, William Cullen Bryant purchased the house from Joseph Moulton (1789–1875), a New York attorney and historian. He and his wife, Leonice Marston Sampson Moulton (1811–1897), pictured in the 1890s, continued to live in cottages near Cedarmere. Leonice became a close friend of Bryant's. (AC.)

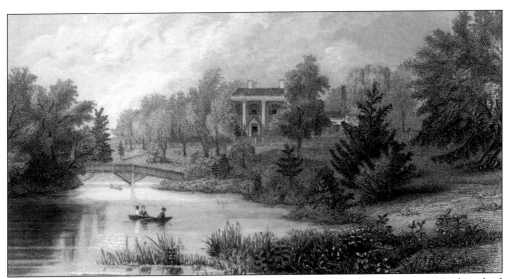

Joseph Moulton's home is depicted from across the pond in 1839. By that time, Moulton had added a piazza with heavy square columns around three sides of the house. The tall chimney of the kitchen dependency is seen to the right of the main house. This is how the building looked when Bryant purchased it. (AC.)

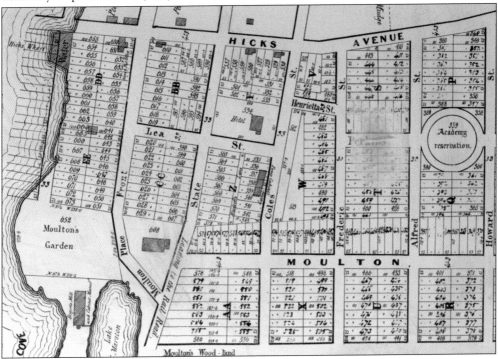

Joseph Moulton hoped to develop the property around Cedarmere into a planned community called Montrose. He expected to attract people who were anxious to escape the city yet wanted the easy access to and from Manhattan via boat that Montrose offered, an idea well ahead of its time. This 1837 survey shows the layout of Montrose, with Cedarmere the large house north of the pond. The project failed, Moulton went into debt, and in 1843, he sold all of the property to William Cullen Bryant. (NC.)

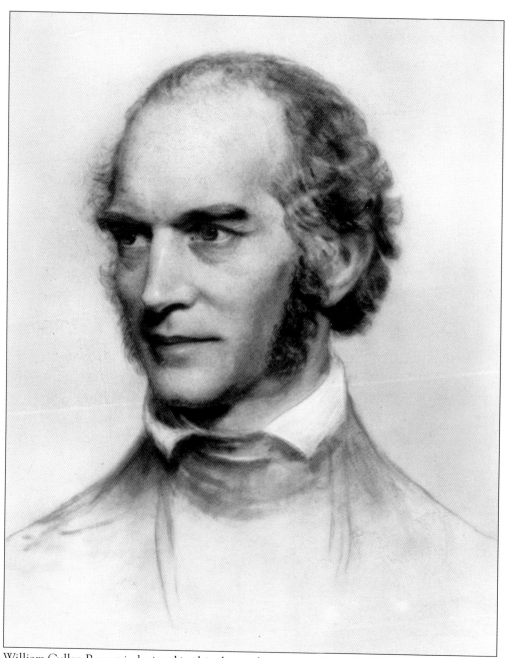

William Cullen Bryant is depicted in this charcoal portrait by Seth Wells Cheney from 1843, the year Bryant purchased Cedarmere. The original artwork is part of Nassau County's Cedarmere collection. At the time Bryant bought Joseph Moulton's estate, he was widely acknowledged as the nation's finest poet and highly regarded as the editor of the influential *New York Evening Post* newspaper. Bryant used the editorial pages of the *New York Evening Post* to champion many civic reforms and significant causes, especially the elimination of slavery. As reflected in his poetry, Bryant was a great lover of nature and had long wanted to purchase a country home where he could relax and indulge his interest in horticulture. When he was almost 50, the success of the *New York Evening Post* finally allowed him to do so. (NC.)

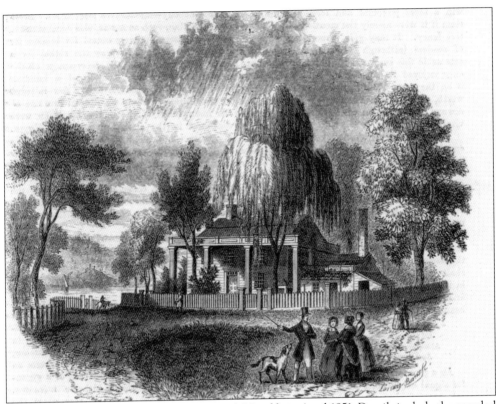

Bryant's house is shown as depicted in *Harper's Monthly* in April 1851. Details include the paneled wooden entry door, a well house below the weeping willow, and a grape arbor in front of the kitchen dependency. The main public roadway is seen running around the harbor side of the house. When originally laid out, it led to the first house on the property, which lay just west of Cedarmere. The path on the right went to the Montrose Hotel. (AC.)

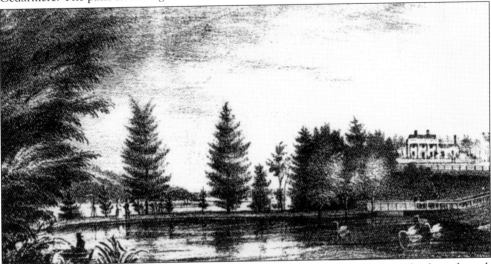

An 1840 print by Bufford shows the house from the southern end of the figure-eight-shaped pond. Bryant named his property Cedarmere after the many cedar trees seen here ringing the mere. Swans still return to the waterway every spring. (NC.)

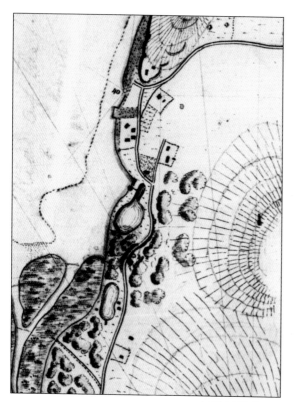

This 1837 US Coast Survey map shows how the roadway curved to the west of Cedarmere, which is just above the larger pond. The arrangement gave Bryant no privacy and divided his house from his vegetable garden, pond, and mill. He solved the problem in 1861 by giving the Town of North Hempstead a new roadway that ran east beyond the house and then turned northwest to connect with the original road. (Roslyn Landmark Society.)

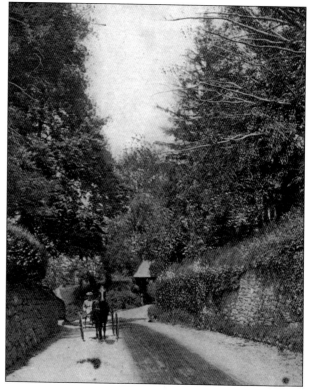

A horse and carriage negotiates the sharp curve around Cedarmere in 1906. This part of the roadway inspired Roslyn author Christopher Morley to write in his 1924 novel *Pandora Lifts the Lid*, "Our course ran past the former home of that venerable poet who penned 'Thanatopsis.' Just outside that house is a dangerous masked curve, and as [we] took it . . . at forty miles an hour, I thought there would be a humorous irony in our being smashed to kindling at the very doorstep of the bard who had written so persuasively about Death." (NCPA.)

Two

CEDARMERE FROM 1860 TO 1878

William Cullen Bryant made several minor improvements to Cedarmere during his first years of ownership, but by 1860, Bryant was wealthy enough that he could turn the house into a showplace. From 1860 to 1861, he had "a troop of carpenters" renovating the building, expanding it to three stories, and adding a large kitchen and laundry wing. When they were done, Cedarmere was a substantial country home of 20 rooms. Although the house was only occupied by William and Frances Bryant, their younger daughter Julia, and two or three servants, the Bryants liked to have guests and included nine bedrooms.

The appearance of Cedarmere was further altered in 1867. Two years earlier, Bryant had engaged an Easthampton, Massachusetts, housewright named Clark to renovate his boyhood home in Cummington, Massachusetts, which he had purchased as a summer home. Bryant was so pleased with the work that he had Clark come to Cedarmere to make similar alterations. He added the bay windows and latticework columns that still grace the building, as well as a gambrel roof and decorative dormers. On returning from a long trip, Bryant declared that "Mr. Clark . . . changed the appearance of my house so that . . . I hardly knew it." Seven years later, Bryant engaged the architect Thomas Wisedell to make further changes, installing indoor bathrooms, enlarging Julia Bryant's bedroom, and redesigning the third-floor dormers. Wisedell subsequently worked with famed landscape architect Frederick Law Olmsted in renovating the Capitol in Washington, DC.

Bryant saw Cedarmere as a retreat where he could relax and commune with nature. He never conducted newspaper work here, preferring to concentrate on his poetry and projects, such as his translations of the *Iliad* and the *Odyssey*. He delighted in walking the grounds, swimming in the harbor, and planning the landscaping around the house. Bryant, who was largely vegetarian, had a particular passion for fruit trees, planting many varieties of pears, apples, plums, and cherries on the grounds.

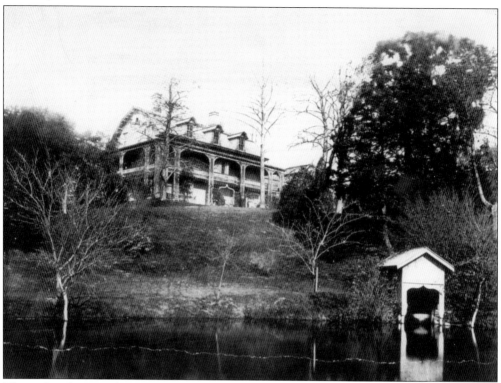

The earliest known photograph of Cedarmere was taken by Rockwood around 1868. It shows the house after the gambrel roof and latticework columns had been added the previous year. It has been identified as the oldest photograph by the tree at the left-hand corner of the house; in all other photographs, the tree has been cut down. (NC.)

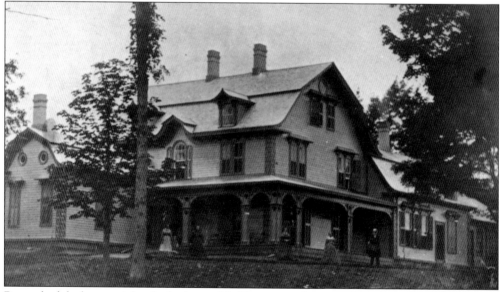

Bryant had the housewright who had remodeled his summer home in Cummington, Massachusetts, perform a similar job at Cedarmere. In this 1866 photograph of the Cummington house, the similarities between it and Cedarmere are striking. (AC.)

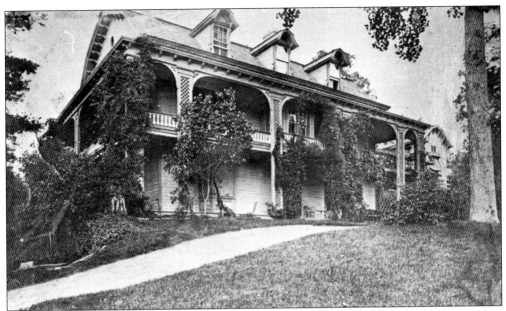

The front of Cedarmere is featured in this photograph taken around 1870 by Bryant's eldest grandson, William Cullen Bryant Godwin. In this close-up view, the latticework columns and dormers on the house are clearly reminiscent of those at Cummington. Only a stump remains of the tree seen in the photograph on page 16. (NC.)

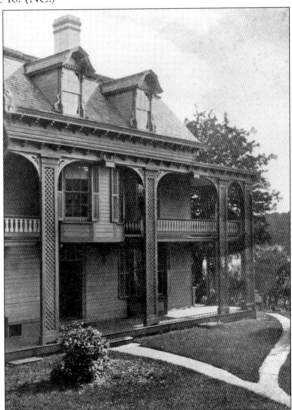

This is the back of the main house as photographed around 1870. Bryant, the nature-loving poet, made sure to have birdhouses hung from the porch roof. The bay projecting from the second story is a sewing room. Above, the gambrel-roofed dormers with their sinuous side brackets help identify this as an early photograph, as the dormers were reshaped in 1874. (NC.)

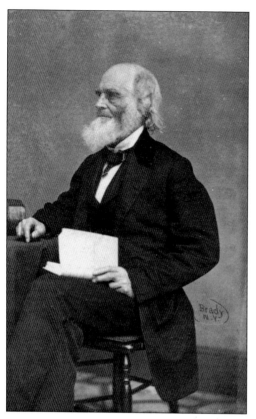

The editor of the *New York Evening Post* is seen in a c. 1860 photograph by Mathew Brady (left). This is how Bryant appeared during the Civil War. He grew his beard during a trip to the Near East in 1853. When he returned to New York tanned and bearded, a member of his own staff sent to meet him at the docks did not recognize him. In a rare display of his sense of humor, Bryant donned a Turkish fez and robes and, speaking broken English, convinced the lady living next door to Cedarmere that he was a foreigner. He even posed in the outfit for New York photographer Charles Fredricks (below). (Both, AC.)

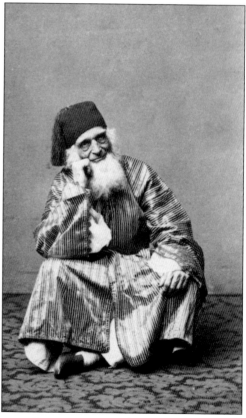

William Cullen Bryant lived at Cedarmere with his wife, Frances (pictured), and younger daughter, Julia. Bryant married Frances Fairchild (1797–1866) in 1821, when he was a young lawyer in Great Barrington, Massachusetts. Bryant loved his wife dearly and wrote two of his most heartfelt poems—"Oh Fairest of the Rural Maids" and "The Twenty-Seventh of March,"—about her, the latter in honor of her birthday. Bryant delighted in reading to her in the parlor at Cedarmere. As she got older, her health deteriorated, and he often nursed her using the homeopathic medicine he practiced. (AC.)

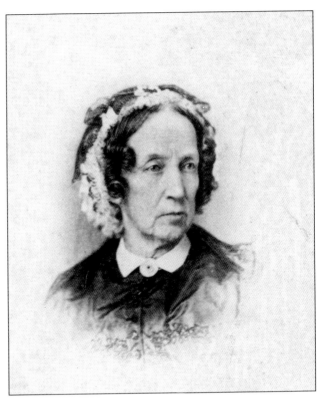

Julia Sands Bryant (1831–1907) was born after the Bryants moved to New York and named for the sister of one of the poet's closest friends there, the author Robert Sands. Julia's father saw to it that she received a good education, even encouraging her to write letters to him in Italian so she could become more proficient (Bryant himself could read German, French, Spanish, Portuguese, Italian, Latin, and Classical Greek in addition to English). Julia never married, and after her mother died, she acted as hostess for her father. (NC.)

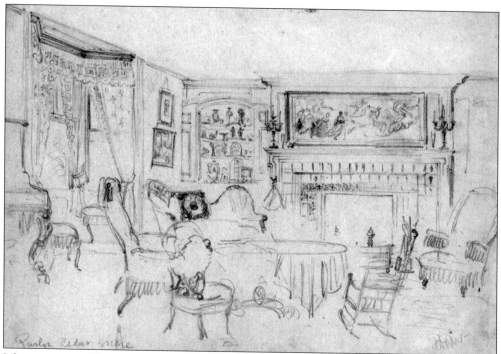

Like most proper Victorians, the Bryants conducted their formal entertaining in the parlor, which is illustrated above in an 1877 sketch by Alfred Waud. Furnishings include a large engraving of *Aurora* over the mantle, grand tour souvenirs in the cupboard, an upright piano, and ample seating for guests. Waud's artwork was the basis for the print seen below showing the room in *Scribner's Monthly* in 1878; much detail was lost in translating the original sketch to a woodcut. Here, William Cullen Bryant often read poetry and the news to Frances and Julia and welcomed many visitors, some of whom are profiled in the following pages. (Above, Historic New Orleans Collection; below, AC.)

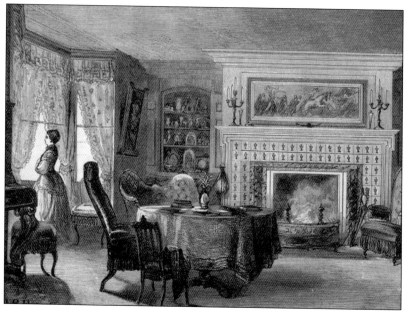

Thomas Cole was the founder of the Hudson River School, an artistic movement that glorified the sublime beauty of the American landscape. Bryant met him shortly after moving to New York, and became an early supporter of the movement. Following Cole's death in 1848, he and Bryant were commemorated in the famous painting *Kindred Spirits* by Asher B. Durand, who also visited Cedarmere. The painting was presented to Bryant and hung in the parlor for many years. (Library of Congress.)

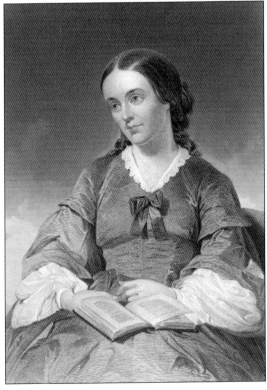

Margaret Fuller was an early advocate of women's rights in America. She was also one of the nation's first women reporters, writing for Horace Greeley's *New-York Tribune*. Fuller became friends with Ralph Waldo Emerson and the Parke Godwins through the transcendental philosophy they shared. She visited the Godwins and the Bryants several times before her premature death in a shipwreck off Fire Island, New York, in 1850. (AC.)

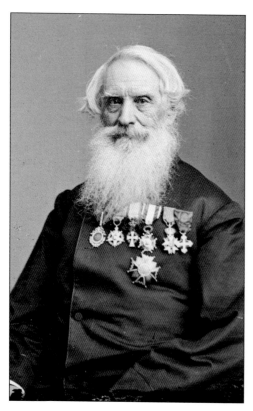

Samuel Morse, the inventor of the telegraph, was also an accomplished artist who met Bryant when the poet moved to New York in 1825. On one occasion when he visited Cedarmere, Morse and his host sat chatting together on a low tree branch behind the house, prompting Frances Bryant to tell a friend who had stopped by that she should walk around and "see the two boys." (Library of Congress.)

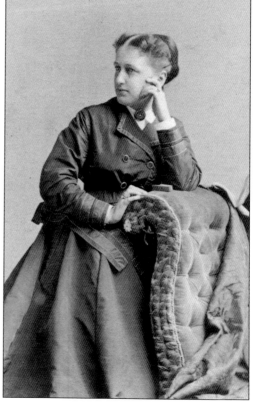

Candace Wheeler, a contemporary of Bryant's daughters, became one of the leading tastemakers and interior designers in the country in the years following the Civil War. She and her family had a home on Long Island and often visited the Bryants. This image comes from Julia Bryant's photo album. (Trustees of Reservations Archives and Research Center.)

William Cullen Bryant and his friend Peter Cooper (right) are pictured around 1875. Although this photograph is often thought to have been taken at Cedarmere, it was actually posed in a New York photographer's studio. Cooper constructed the first American steam locomotive and founded the Cooper Union school in Manhattan. In 1876, he ran for president of the United States on the Greenback Party ticket against Republican Rutherford Hayes and Democrat Samuel Tilden, who was also a friend of Bryant's. Despite this, Bryant and the Republican *New York Evening Post* supported Hayes. (AC.)

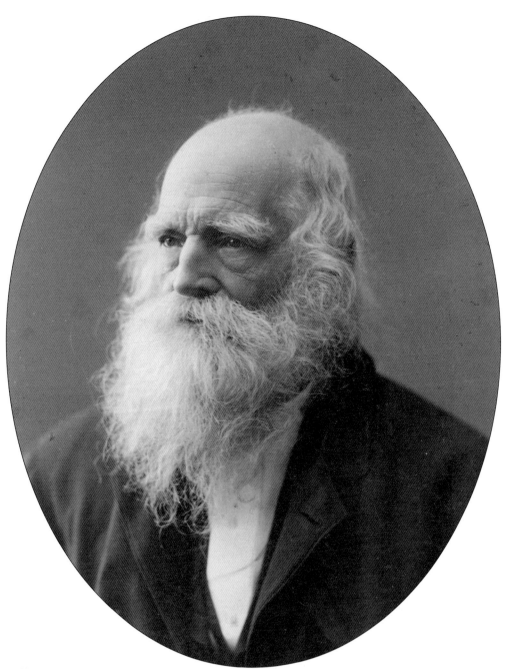

William Cullen Bryant grew his full beard and moustache shortly after the Civil War. He is most often depicted this way, as a man in his 70s or 80s. Bryant's distinguished appearance, coupled with his wisdom and speaking abilities, earned him the nickname "Nestor of American poets." (AC.)

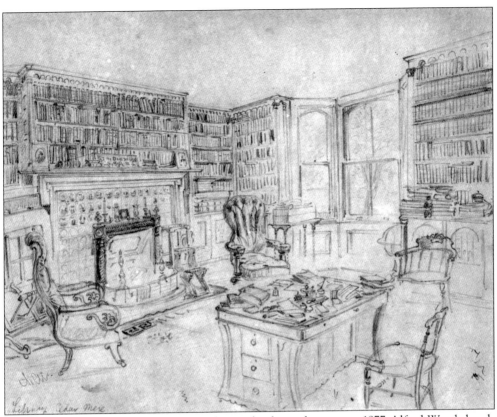

The heart of Cedarmere for Bryant was his study, shown here in an 1877 Alfred Waud sketch (above) and an 1878 *Scribner's Monthly* print (below). Bryant refused to do any newspaper work here, reserving his time at Cedarmere for his personal writing and correspondence. Here, he composed numerous poems and translated the *Iliad* and the *Odyssey*, a project he undertook in his seventies to dull the pain of his wife's death. The study contained hundreds of books on various topics of interest, including history, theology, natural science, homeopathic medicine, philosophy, and current events, as well as literature and poetry. (Above, Historic New Orleans Collection; below, AC.)

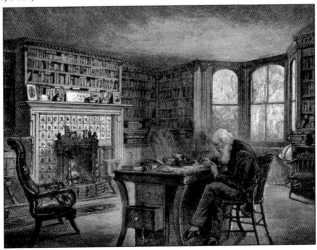

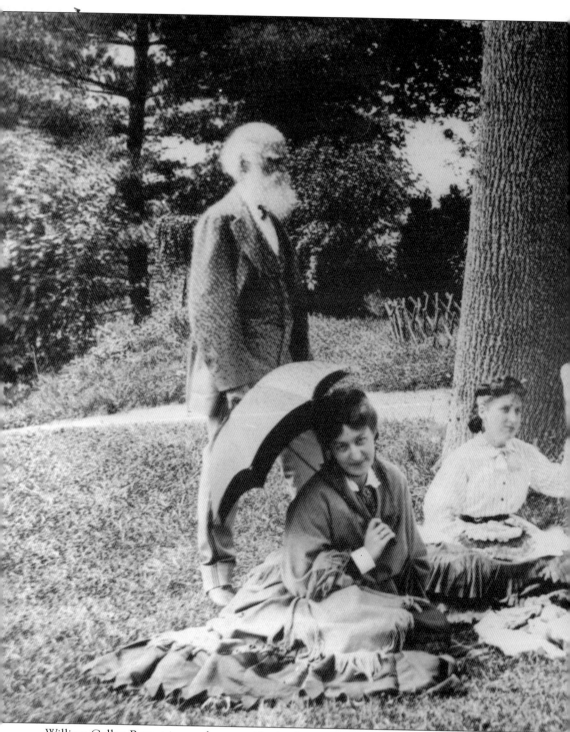

William Cullen Bryant is seen here outside the front of Cedarmere around 1870 in a rare half-plate tintype. From left to right are Bryant, Laura Leupp, Anna Fairchild, Anna Godwin, Minna Godwin, and Julia Bryant. Leupp was the orphaned daughter of Bryant's friend Charles Leupp; she took a trip to Europe with the poet and Julia from 1866 to 1867. Fairchild was Julia Bryant's

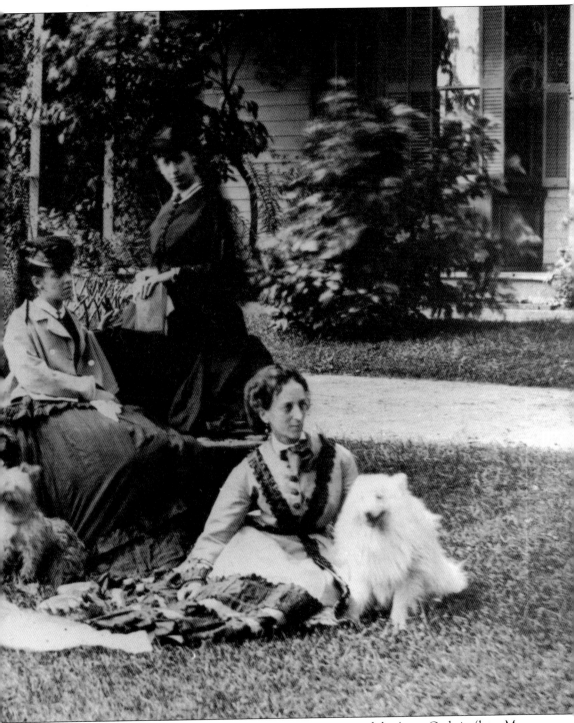

cousin on her mother's side and her constant companion as an adult. Anna Godwin (later Mrs. Alfred de Castro) and her sister Minna (later Mrs. Frederic Goddard) were daughters of Julia's sister Frances Godwin. As tintypes produce mirror images, this photograph has been reversed. (Bryant Library Local History Collection, Roslyn, New York.)

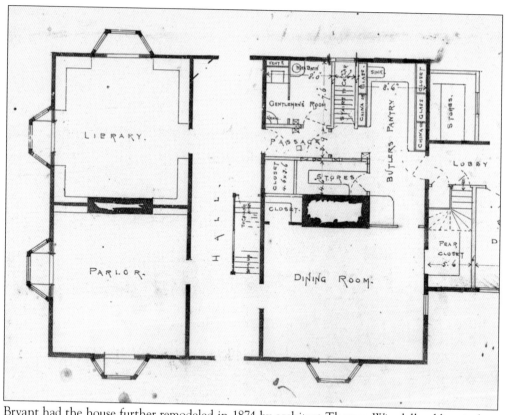

Bryant had the house further remodeled in 1874 by architect Thomas Wisedell, adding indoor plumbing and renovating the butler's pantry, among other changes. The layout of the first floor of the main house is shown here in Wisedell's plan. (NC.)

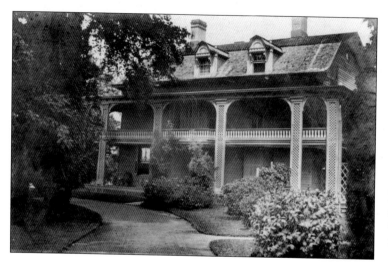

This photograph taken around 1875 highlights the ornate dormers refashioned by Wisedell. Wisteria frames the entrance to the house. The heart-shaped trellis above the entrance was later used in the garden (see page 112). (NCPA.)

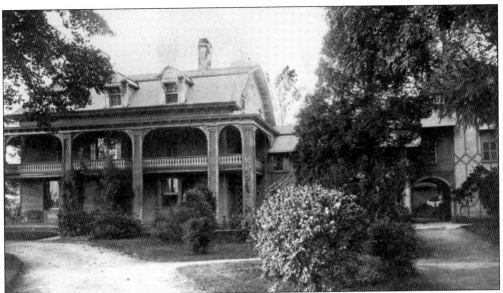

This view of the front of Cedarmere was photographed around 1875. Laundry can be seen hanging through the arch that permitted deliveries to the rear of the building, where the kitchen, laundry, and icehouse were located. (NC.)

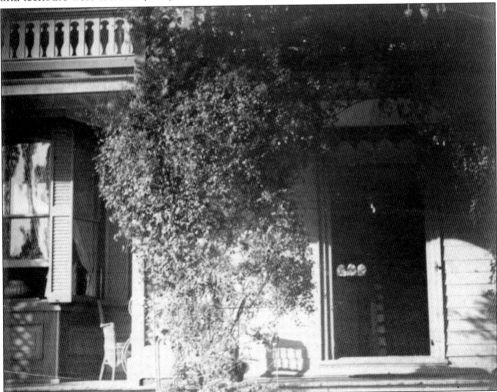

Taken around 1900, this image of the front entrance of the house is the only known photograph that shows the main hallway and stair. The four small windows above the door frame are still in place. The shade of a kerosene lamp can be seen in the parlor window to the left. (NC.)

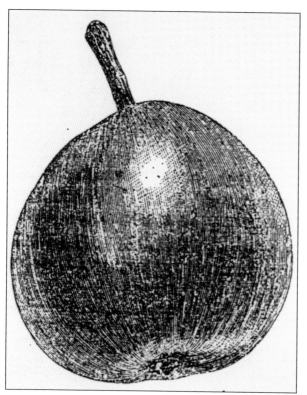

William Cullen Bryant enjoyed all fruit, but he had a particular taste for pears. He planted a wide variety of pear trees at Cedarmere that ripened at different times so that he could have fresh pears from spring until the winter. He even developed his own hybrid, the Cedarmere pear. It is seen on the left in an illustration from the *Horticulturist* of September 1863, which declares, "Mr. Bryant is probably the only poet who ever raised a good seedling pear." Bryant's passion for the fruit led to two unusual features at Cedarmere. At the end of the house nearest the street, he had a pear tower constructed (seen below at left in a print from *Scribner's Monthly*) to store his harvest until needed. Adjacent to the dining room of the main house, he had a pear closet with shelves built, where the fruit could be left to ripen; this is visible in the floor plan of the house on page 28. (Both, AC.)

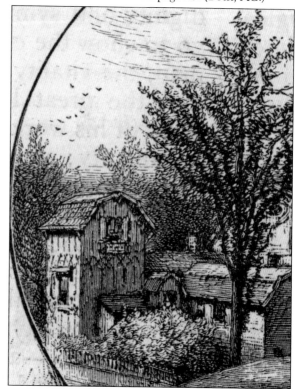

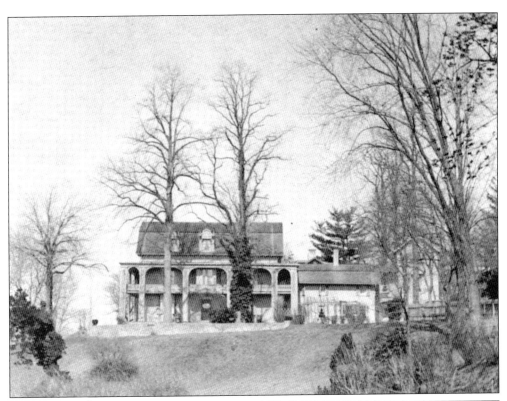

The massive tulip tree (left) and locust tree in front of Cedarmere dominate this photograph taken around 1890. While the tulip tree was removed more than a century ago, the locust survived until the 1960s. Also visible in this photograph is the oval window William Cullen Bryant put into Cedarmere's front door. This renovated Dutch door, seen on the right in artwork by Charles A. Vanderhoof, still overlooks the pond at Cedarmere. (Above, NC; right, AC.)

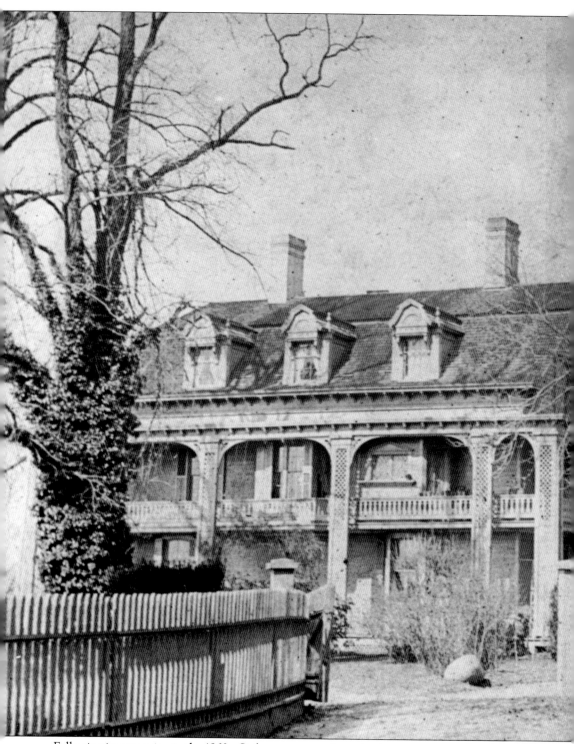

Following its expansion in the 1860s, Cedarmere was an imposing house, as seen in this photograph taken around 1890. The main block of the house contained the parlor, study, dining room, butler's pantry, and family quarters. To its right were the kitchen and servants' quarters. Beyond that,

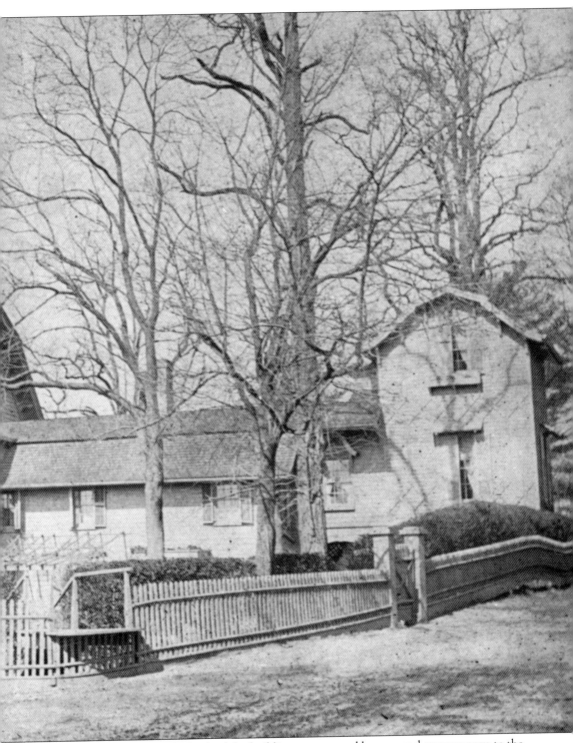

the carriageway leading to the back of the building was covered by a second-story passage to the pear tower at far right. (Roslyn Landmark Society.)

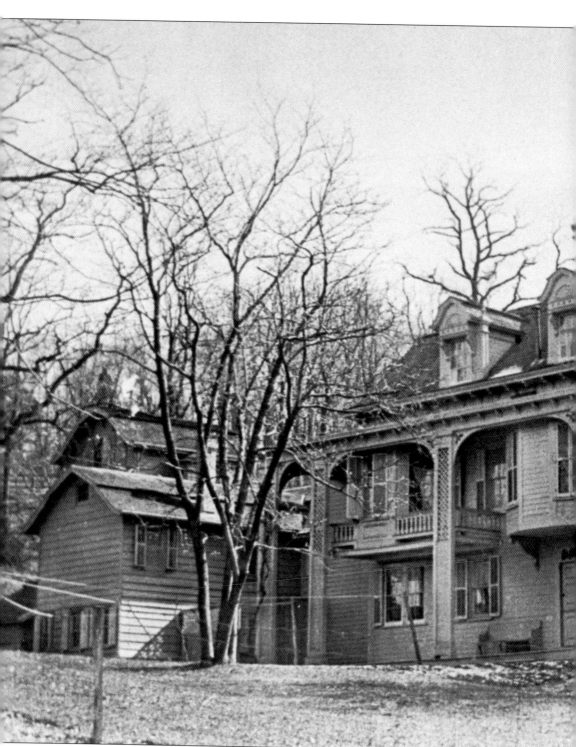

The back of the main house is pictured in a rare view from around 1900. On the far left is the pear tower. Next to it, perpendicular to the rest of the house, is the kitchen and laundry wing. On the second floor of the main house, the expansion of Julia Bryant's bedroom onto the balcony can

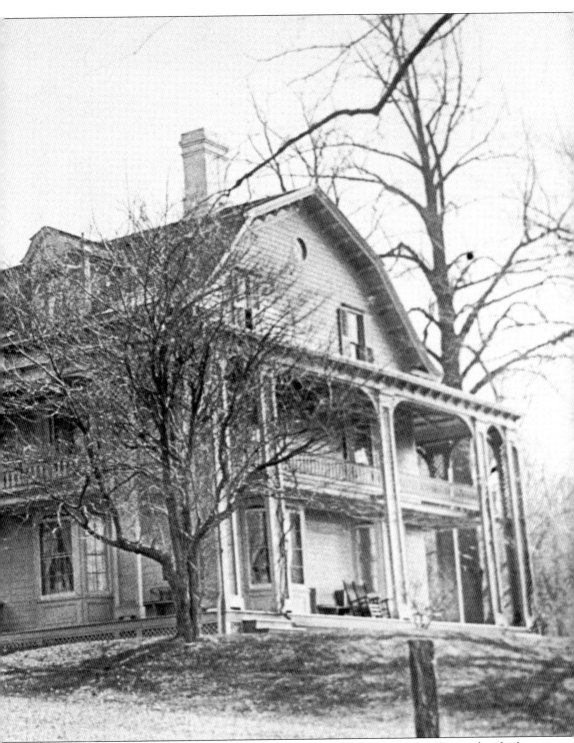

be seen left of center, adjacent to the sewing room bay. The Dutch door onto the porch, which was part of Richard Kirk's original building, was later removed and used as the entry door for the restored Roslyn Grist Mill. (NC.)

William Cullen Bryant often sat on this rustic iron bench outside the front door of Cedarmere to look at the ponds and bridge. The original bench is preserved in Nassau County's Cedarmere collection. (Roslyn Landmark Society.)

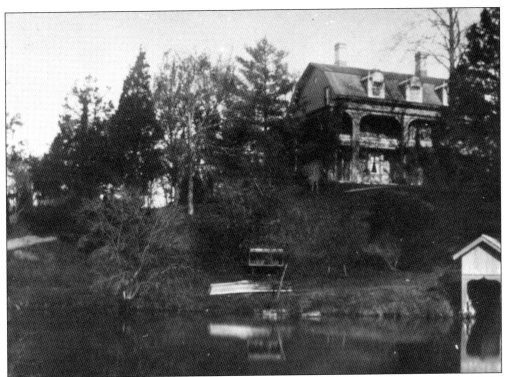

The house as seen from the pond is shown as photographed by George Brainard in August 1875. The small boathouse on the right dated to Joseph Moulton's time. It stood until the 1960s, when it collapsed; it has since been re-created through the generosity of the Roslyn Landmark Society. On the shore to its left is the upturned rowboat that was usually kept in the boathouse. Behind the boat is a small duck house. (NC.)

The photographer George Rockwood captured three of William Cullen Bryant's grandchildren playing in front of the pond in this photograph taken around 1868. Their small model sailboat is faintly visible in the water to the children's left. (Trustees of Reservations Archives and Research Center.)

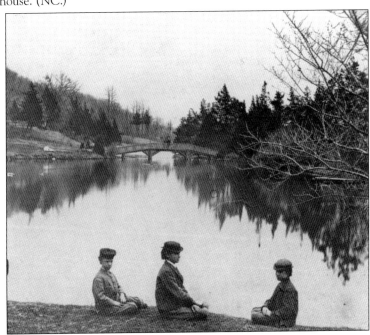

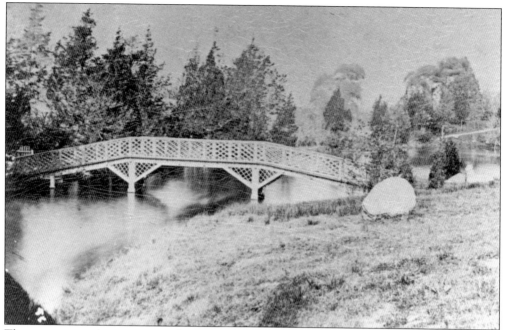

There were several structures on the property around the main house. This is the original bridge at Cedarmere, viewed from the south. This latticework bridge was constructed by Joseph Moulton to span the narrow waist at the center of the figure-eight pond. Bryant had it painted a light ochre, "the color of new wood." (NC.)

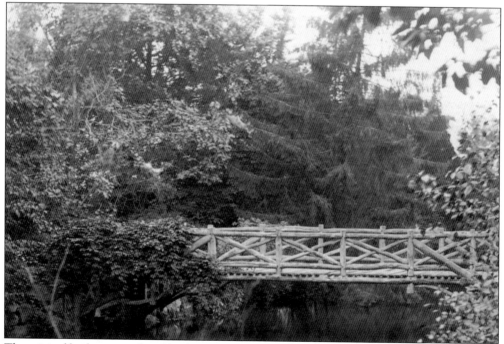

The original bridge was replaced by this rustic-looking wooden bridge around 1875. Both structures appear in photographs and prints of Bryant made around that time, which has helped date the feature. (NC.)

William Cullen Bryant and his family and guests enjoyed swimming in the salt water of Hempstead Harbor adjacent to Cedarmere. For their convenience, he eventually had two bathhouses. The older (above) was built before 1865, when it was included in a survey of the property. It was located on the west side of the pond, south of the bridge. The newer bathhouse, seen below in a 20th-century photograph, was constructed by Roslyn carpenter Washington Losee to Bryant's specifications in 1866. It stood on the shore north of the Cedarmere mill. (Both, NC.)

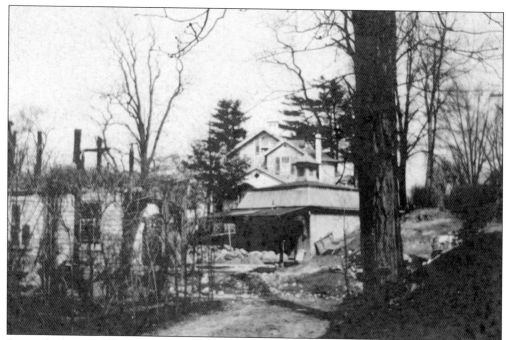

Bryant had a sizeable brick icehouse (center, with overhang) placed just north of the house in 1867. In addition to storing ice harvested on Bryant's pond, it served as a milk house, where pans of fresh milk could be left to cool so the cream would rise. The building, seen here in a 1903 photograph, was converted into a garage in the 1920s. (NC.)

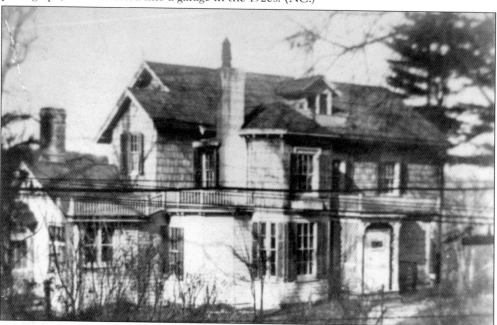

Just north of the icehouse was a house constructed for the use of Bryant's estate manager, George Cline, around 1860. Originally a simple cottage, over time it was given a number of haphazard additions, as seen in this 20th-century photograph. After housing a series of tenants, it was torn down in 1971. (NC.)

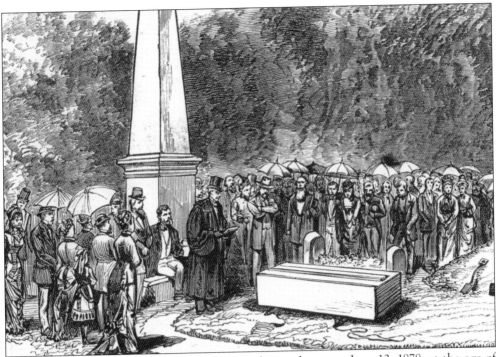

William Cullen Bryant passed away in his Manhattan home on June 12, 1878, at the age of 83. After an impressive funeral at All Souls Unitarian Church in New York, Bryant's remains were brought to the Roslyn Cemetery for interment. Bryant had purchased the circular plot and erected the large granite obelisk (below) after his wife Frances died in 1866; the poet was laid to rest by her side. Since then, three generations of his family have been buried in the cemetery on Northern Boulevard in Roslyn. (Both, AC.)

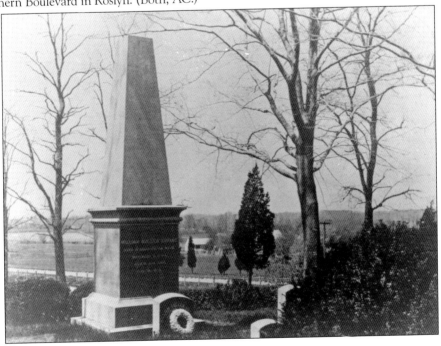

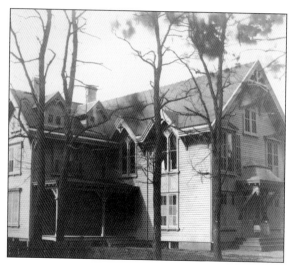

William Cullen Bryant continues to be revered in Roslyn. In addition to Cedarmere, he is commemorated by the public library. In 1874, he had this building constructed north of Roslyn to serve as a library and meeting place. Known as the Hall, it was donated to the community after Bryant's death and renamed the Bryant Library. The original structure was torn down in 1946 for the construction of the Roslyn viaduct. The library was moved into the Roslyn War Memorial Building in 1952 and is still a center of community life. (Roslyn Landmark Society.)

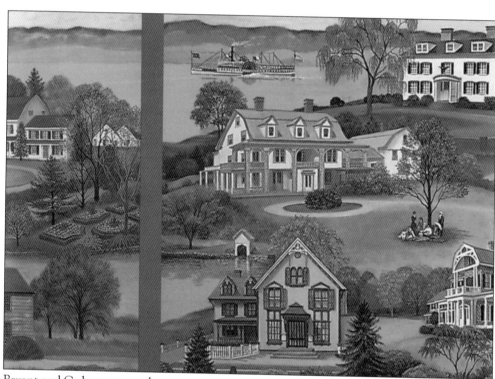

Bryant and Cedarmere are also commemorated in the main branch of the Roslyn Savings Bank on Old Northern Boulevard. In 1995, the bank unveiled a mural by Frances Norris Streit in its lobby, which depicts scenes of historic Roslyn. Among its scenes is this view of Cedarmere with its gardens and pond; below it is the Hall. Along the lower border of the mural are portraits of Bryant and his daughters. (Roslyn Savings Bank, artwork by Frances Norris Streit.)

Three

MONTROSE AND THE
NORTHERN ESTATE

After William Cullen Bryant's death in 1878, his Cedarmere estate was divided between his two daughters, Julia and Frances. The elder girl, Frances (1822–1893), was married to author and newspaper editor Parke Godwin (1816–1904) when Bryant bought Cedarmere, so she never lived in there. Instead, the poet had a cottage named Goldenrod built for them at the opposite end of the pond (see chapter 4). By 1852, the Godwins and their five children (eventually eight) had outgrown the cottage, so Bryant purchased Montrose, a former inn across the road, for their use.

Frances inherited Montrose and the 85 acres of woodland in the northern half of Bryant's estate. The property included a colonial-era house purchased from the two spinster Mudge sisters, four additional houses, and a large barn. Over the following years, these buildings were rented to tenants, including estate workers and some of the Godwin children, among them Harold Godwin and his sister Fanny, with her husband, Alfred White.

After Frances and Parke Godwin passed away, Montrose became the home of their daughter Minna (1846–1927) and her husband, Frederic Goddard. When Minna's brother William Cullen Bryant Godwin died in 1895, they adopted his 10-year-old son Conrad (1885–1974). Conrad and his family lived at Montrose until 1955, when Minna's family trust opted to sell the northern estate. The Roslyn Harbor property was developed for housing, and all but one of the Bryant-era buildings have survived.

Frances Bryant (1822–1893), known as Fanny, was William Cullen Bryant's elder daughter. She married Parke Godwin in 1842 while her family was still living in Manhattan, so she never resided with her parents in Cedarmere. She and Parke had eight children, six of whom—four girls and two boys—survived to adulthood. After her father's death, Frances inherited the northern half of his Roslyn estate. (NC.)

Parke Godwin (1816–1904), a graduate of Princeton, became an assistant editor at the *New York Evening Post* in 1837 and continued to be an editor at the paper for most of his career. After Bryant's death, he managed the paper until 1881. In addition to his newspaper work, Godwin contributed to magazines, such as the *Atlantic Monthly*, and wrote several books. (NC.)

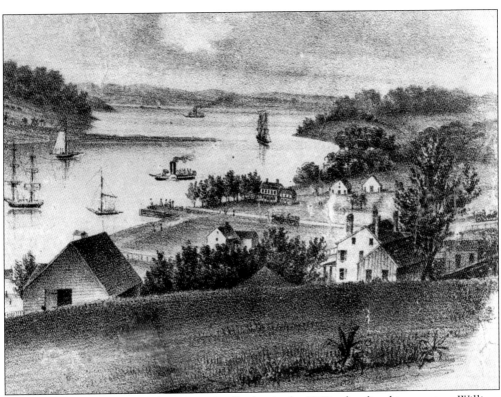

When Parke and Frances Godwin moved to Roslyn in the 1840s, they lived in a cottage William Cullen Bryant built for them on the pond at Cedarmere (see page 61). When their growing family required larger living quarters, Bryant purchased the old Montrose Hotel across the street from Cedarmere for their use in 1852. At that time, it was a simple Georgian building with four chimneys, as shown in the foreground of this print. (AC.)

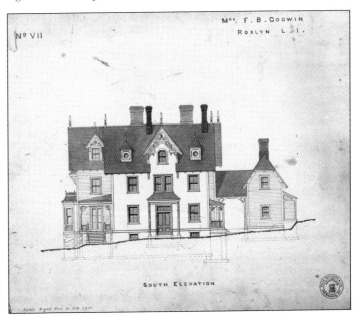

In 1869, the Godwins hired New York architect Calvert Vaux to expand and remodel Montrose. Vaux, who knew both Parke Godwin and William Cullen Bryant, had been the codesigner of Central Park along with Frederick Law Olmsted, another of Bryant's friends. This is Vaux's plan for renovating the south side of the building, which is also shown above. (Library of Congress.)

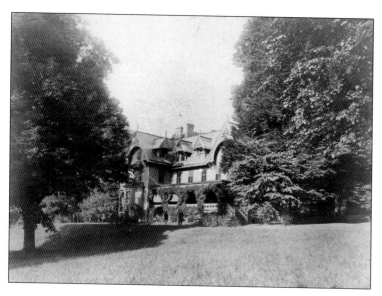

Calvert Vaux's heavily ornamented version of Montrose was a vast improvement over the original Montrose Hotel building. On the lawn in this view of the house's west side are Frederic N. Goddard, husband of the Godwins' daughter Minna, and artist Eastman Johnson. (Bryant Library Local History Collection, Roslyn, New York.)

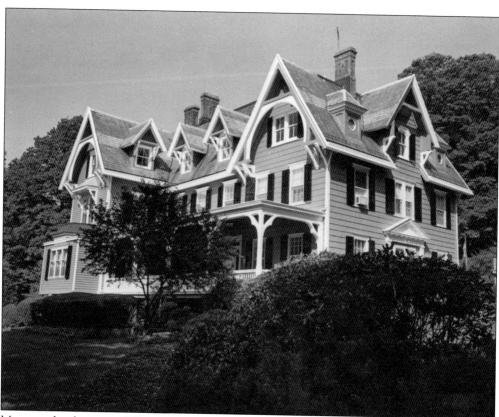

Montrose has been carefully preserved by subsequent owners as one of the architectural gems of Roslyn Harbor. (Roslyn Landmark Society, photograph by Ray Jacobs.)

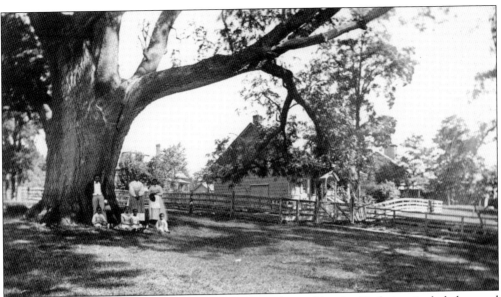

The northern part of Bryant's Cedarmere estate, inherited by the Godwins, included several buildings and landmarks. One of its most notable was this enormous black walnut tree, the largest on Long Island. Behind the tree are Stone House (left) and the Mudge Cottage (right), with the site's large barn at back right. This photograph was taken before the Mudge Cottage was moved in 1884. The African American family under the tree are the Eatos, who lived on the Mudge farm for many years. (Roslyn Landmark Society.)

This photograph, labeled "the poet's favorite walk," shows part of the fields and woodlands of the Godwins' estate in 1904. Most of the family's property east of Montrose looked like this. (NC.)

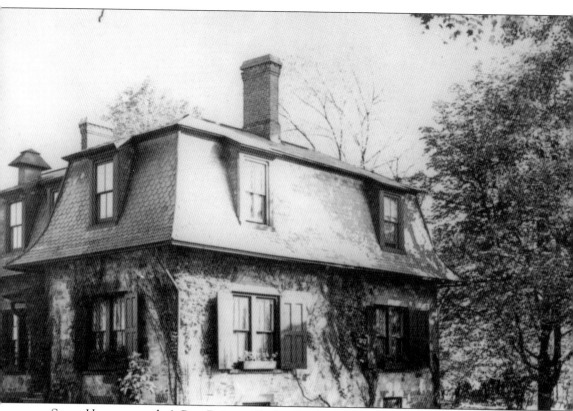

Stone House, on today's Post Drive in Roslyn Harbor, was constructed from the material of a large erratic boulder that was nearby. It was designed by William Cullen Bryant's estate manager, George Cline, as a home of his own in 1867 while Bryant was on a trip to Europe. When the nature-loving poet returned, he was so angry about the destruction of the landmark rock that he stopped work on the house. The interior was not completed until 1884. (NC.)

The 18th-century Mudge Cottage was the home of Quaker sisters Amy and Elizabeth Mudge, who sold their house and farm to Bryant in 1868. The well-preserved building has been moved several times and is now located on Motts Cove Road South. (AC.)

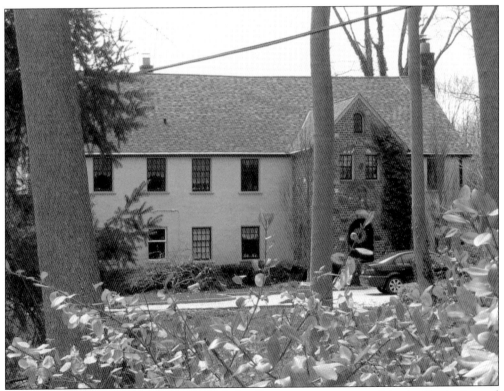

The barn that served Stone House and Mudge Cottage was constructed in the 1870s. Around 1920, it was sold to Robert Patchin and moved to Bryant Avenue near Motts Cove Road North. There, it was remodeled into a house by Patchin's brother-in-law and well-known architect John Russell Pope. (AC.)

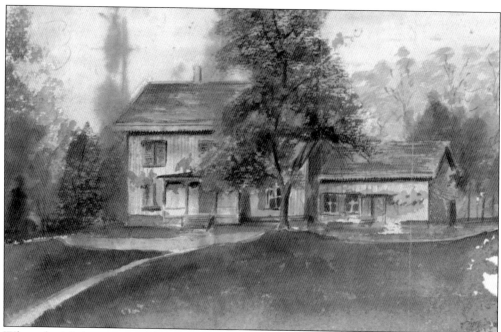

When the Mudge sisters sold William Cullen Bryant their farm, it was with the promise that Bryant would build them another cottage in which to live. He constructed what later became known as Sweet Briar, named after a large sweetbriar rosebush nearby. The house originally had board-and-batten walls, as seen in the painting by Harold Godwin above. In the early 1900s, the second story was refinished with cedar shingles. The house remained on today's Harbor Lane until the 1990s. (Above, NC; below, Bryant Library Local History Collection, Roslyn, New York.)

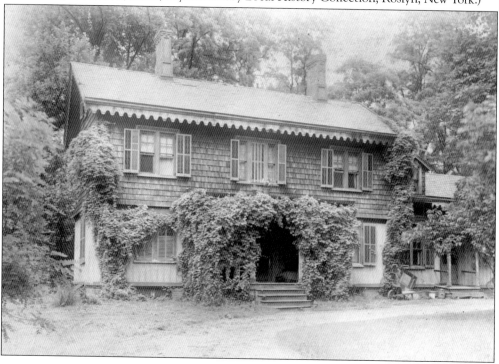

Boxwood Cottage, on the hill east of Montrose, was probably constructed in the 1830s as an outbuilding for the Montrose Hotel. In 1869, it was moved up the hill to its present location and given a lean-to addition. It is named for the large boxwood bushes in the front yard. (Roslyn Landmark Society.)

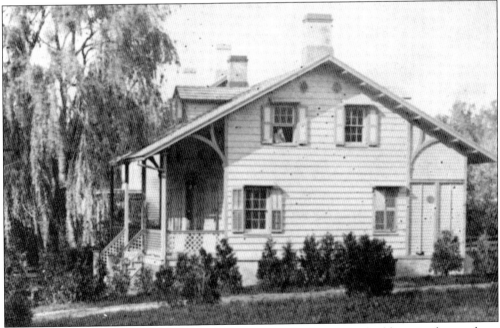

Springbank, on Bryant Avenue north of Montrose, is the last of the buildings in the northern section of Bryant's Cedarmere estate. Bryant bought the house from Stephen Smith in 1868, when it was about 30 years old. It was moved a bit to the north of its original location in the 1880s, when it was probably given its distinctive chalet-style appearance. It was named Springbank after the active water springs around it. (Roslyn Landmark Society.)

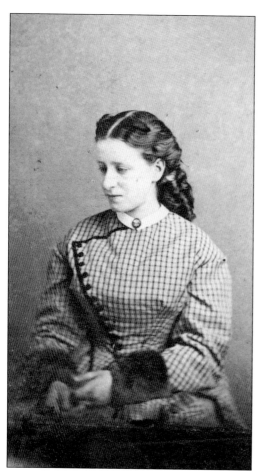

After Frances Godwin died in 1893, ownership of her Montrose holdings passed to Parke Godwin, who gave it to their daughter Minna Godwin Goddard (1846–1927), pictured at left. When she died, it was inherited by her adopted son and nephew, Conrad Godwin Goddard, pictured below. He managed the estate until 1955, when rising taxes forced him to sell the property for development. (Both, NC.)

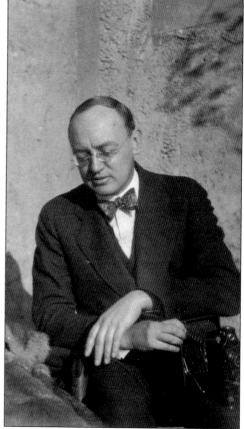

Four

CEDARMERE AND THE SOUTHERN ESTATE

William Cullen Bryant's younger daughter, Julia Sands Bryant (1831–1907), inherited the southern portion of Bryant's estate after his death in 1878. Her 85-acre parcel consisted of Cedarmere, Bryant's upland farm to the east, two mills, and four cottages to the south. Julia's bequest also included her father's brownstone in Manhattan and his summer home in Cummington, Massachusetts.

After settling her father's affairs, Julia moved to Paris, France, with her cousin and companion Anna Fairchild. Julia only occasionally returned to Roslyn and, in 1891, decided to sell Cedarmere to her sister's youngest son, Harold Godwin (1858–1931). Harold was an avid golfer and turned the upland farm into a private nine-hole golf course, one of the first in the country. He also enlarged the Jerusha Dewey Cottage by raising it and building a new first floor beneath it.

In 1899, Godwin sold the upland farm property to publisher Lloyd Bryce, who built a mansion there. Bryce also purchased the land south of Cedarmere's pond, including three cottages and the Old Red Mill. Nineteen years later, Bryce's heirs sold the property to steel magnate Henry Clay Frick as a home for his son Childs Frick and his wife, Frances. The acreage around the mansion is now the Nassau County Museum of Art.

Harold Godwin retained Cedarmere, the Gothic Revival Mill, and Goldenrod cottage at the south end of the pond. He renovated the cottage in a Tudor style, and he and his family lived there on the occasions when he rented Cedarmere to tenants.

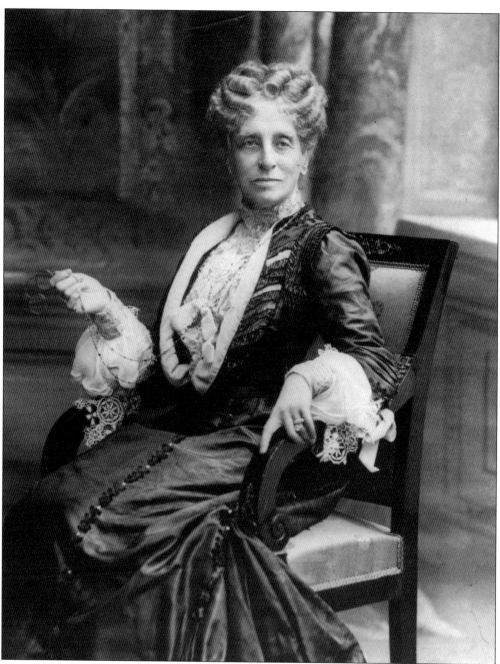

At her father's death, Julia Bryant inherited the southern portion of his Cedarmere estate, including the main house. She soon moved to Paris, France, with her cousin and companion Anna Fairchild. There, Julia lived the life of a grande dame on the rue Galilée, seldom returning to the United States. She died in Paris in 1907 and is buried in the outlying village of Saint-Germain-en-Laye. (Bryant Library Local History Collection, Roslyn, New York.)

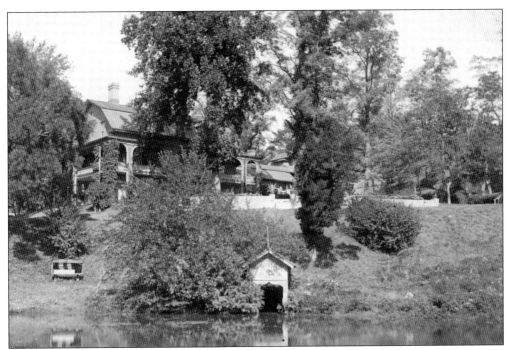

Julia made few changes to Cedarmere during her ownership. One was the construction of a decorative retaining wall in front of the house overlooking the pond. This was probably done when the entrance drive was turned into a circle. (AC.)

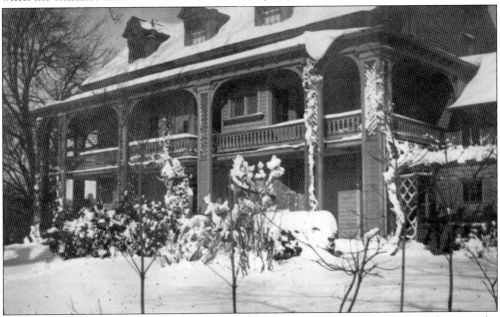

A second alteration was an extension from her father's former bedroom onto the balcony in the front of the house, which was done around 1885. It is the section with diamond pane windows pictured on the second floor of the house. A door on the right side opens onto the balcony. The arrangement was probably inspired by the enlargement of Julia's bedroom on the other side of the house in 1874. (NC.)

Julia's holdings extended from Cedarmere south to the Hall and Bryant's Landing on the outskirts of Roslyn village. The landing was a commercial dock that William Cullen Bryant had invested in and was not formally part of the Cedarmere estate. (AC.)

North of Bryant's Landing was the Old Red Mill, which lay on a large pond that marked the southern end of the Cedarmere estate. It is seen here in a photograph taken around 1875 by Julia Bryant's nephew William Cullen Bryant Godwin. The mill was later rented as an icehouse. (NC.)

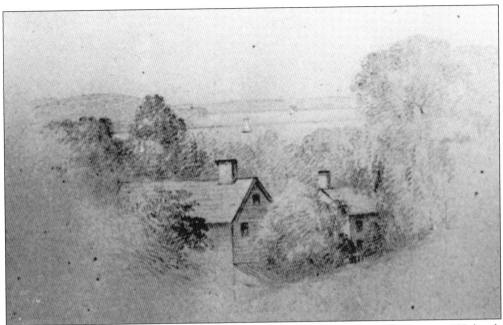

Adjacent to the mill were three cottages along Bryant Avenue. Two are seen here in an 1855 sketch by T. Addison Richards. William Cullen Bryant and later Julia rented these to various tenants, including Leonice Moulton, the widow of Joseph Moulton. One of the cottages is still in place, a second was torn down years ago, and the third was moved to East Broadway in Roslyn, where it has been carefully restored (below). (Above, NC; below, Roslyn Landmark Society.)

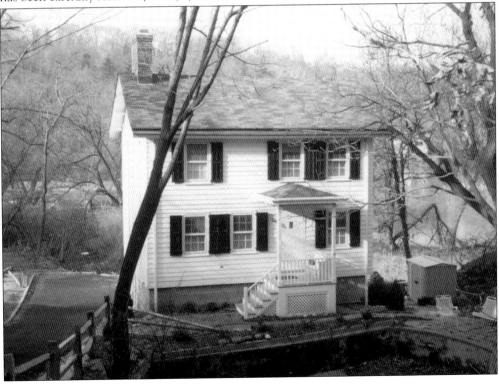

Julia also inherited her father's upland farm across the street from Cedarmere. This was one of the poet's favorite spots. He created walking paths with benches and often went for strolls in the woods. Adjacent to the woods was his farmland, where he raised wheat, corn, oats, and apples and pastured his sheep, cows, and horses. Also here were his barns, depicted in an 1878 print from *Scribner's Monthly*. The barn complex is at the center, Montrose is to the right, and the Cline house north of Cedarmere is to the left. In the harbor is one of the steamboats that the poet used to travel to New York. (Both, AC.)

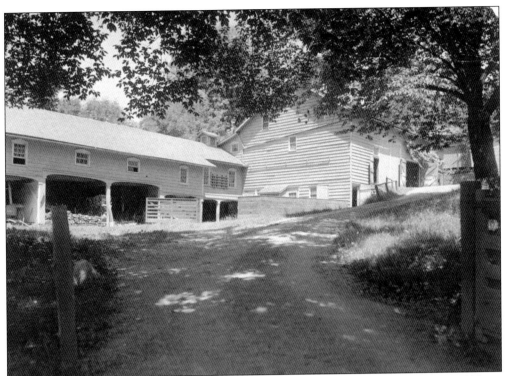

The 1904 photograph above captures the scale of the barn complex. The buildings would have been used to house farm animals and to store carriages and wagons, farm tools, harness, feed, and firewood. The image below shows one of the family drivers in the area at the far right of the image above. The building behind him with the slatted sides was a corncrib. The stone retaining wall below it is still visible on the grounds of the Nassau County Museum of Art. (Both, NC.)

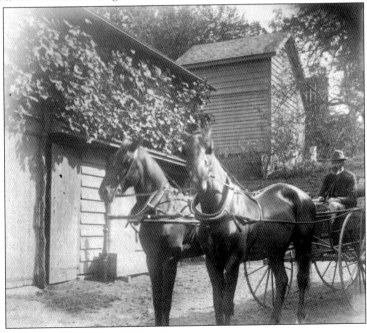

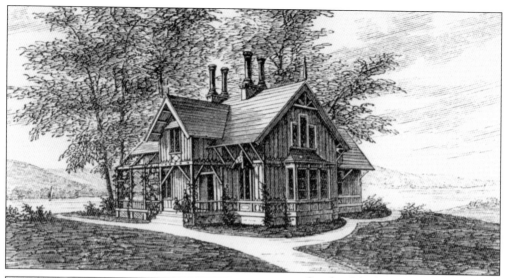

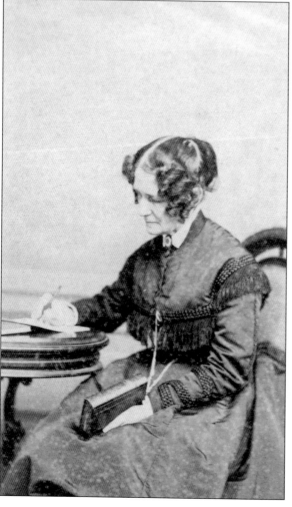

South of the barns was the Jerusha Dewey Cottage. William Cullen Bryant had it built in 1862 to encourage his close friends Rev. Orville Dewey and his sister Jerusha (left) to make long visits to Cedarmere. The one-and-a-half-story house was designed by Frederick Copley of Roslyn, who also did other projects for Bryant. His workmanlike plan was published in *Woodward's Country Homes* in 1865. (Above, Roslyn Landmark Society; left, Trustees of Reservations Archives and Research Center.)

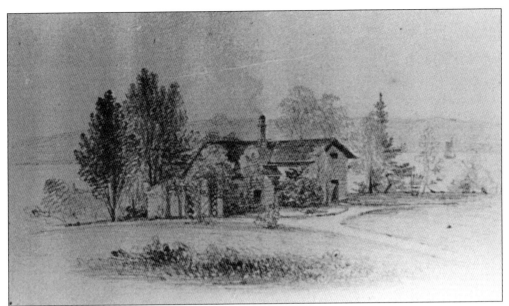

When Bryant purchased Cedarmere, he had a cottage built at the south end of his pond for his elder daughter Frances and her husband, Parke Godwin. The original building, later dubbed Goldenrod, is seen here in its only known depiction, an 1855 sketch by T. Addison Richards. (NC.)

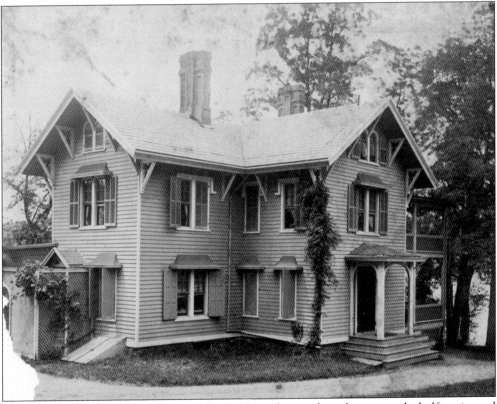

Not long after Addison's sketch was made, Goldenrod was enlarged to two and a half stories and remodeled. This is how the building looked when Julia Bryant inherited it. (NC.)

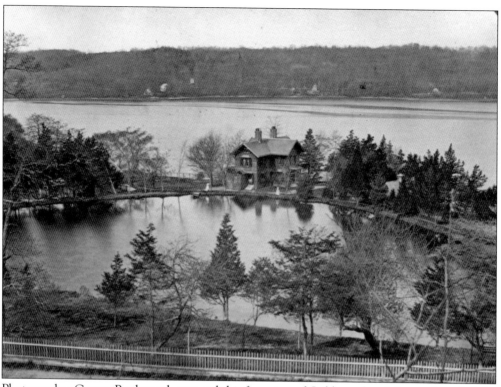

Photographer George Rockwood captured this fine view of Goldenrod and the south end of the pond in 1868. The original is clear enough that croquet wickets can be seen in the lawn in front of the cottage. The roof of Bryant's original bathhouse is poking through the trees to the right. Left of the house, partially obscured by a tree branch, are the carriage shed and horse barn. (Trustees of Reservations Archives and Research Center.)

The carriage shed was later moved closer to Bryant Avenue. In the 1950s, it was converted into a house. Enlarged and improved, it is still a home just south of the entrance to Goldenrod. (NC.)

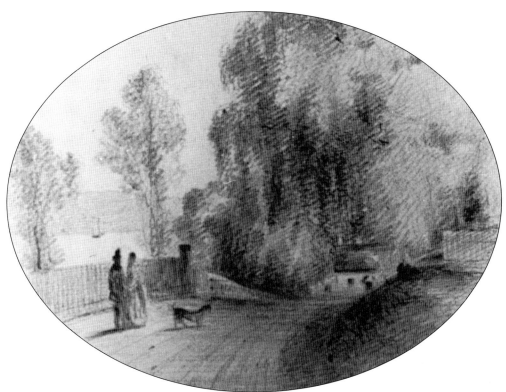

William Cullen Bryant almost purchased one additional building as part of his Cedarmere estate. Around 1860, he considered acquiring the Hicks cottage just north of Cedarmere, shown here in T. Addison Richards's 1855 sketch. His wife objected, so Bryant dropped the idea. The building was replaced in 1863 by this beautiful design with Flemish gables (below) by Frederick Copley, who also designed the Jerusha Dewey Cottage. The house, known as Sycamore Lodge and Clifton, is still a showplace north of Cedarmere. (Above, NC; below, Roslyn Landmark Society.)

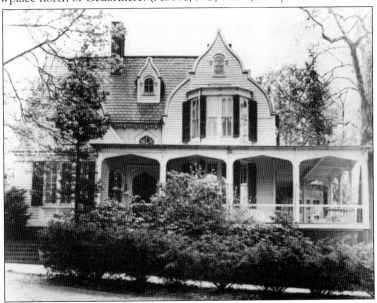

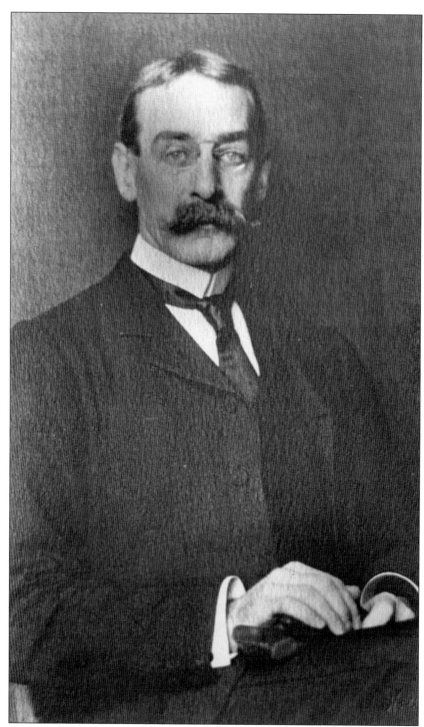

In 1891, Julia Bryant sold Cedarmere and her part of the estate to her sister's youngest son, Harold Godwin (1858–1931). Harold was a graduate of Princeton University and a talented watercolor artist and sculptor. As a young man, he was an art critic for the *New York Evening Post* and other journals, later managing the family's real estate holdings as well. (NC.)

Harold was married to Elizabeth Love Marquand (1862–1951), the daughter of Henry G. Marquand, a millionaire art collector who was one of the founders of the Metropolitan Museum of Art. At the time Harold purchased Cedarmere, they had two children: Frederick, born in 1889, and Elizabeth Love Godwin, then an infant. A year after the family moved to Roslyn, the Godwins' third child, Frances Bryant Godwin, was born. Elizabeth (right) and Frances are seen below at ages 12 and 13. (Both, NC.)

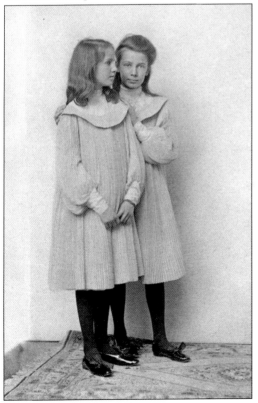

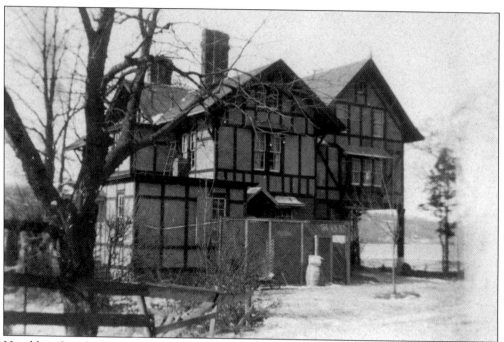

Harold preferred to live with his family at Goldenrod rather than Cedarmere, which he usually rented. He had the cottage enlarged and renovated in a Tudor style. (NC.)

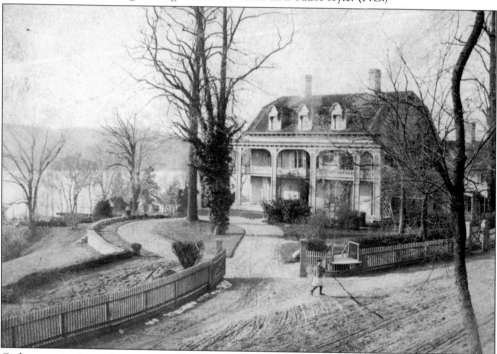

Cedarmere is pictured as it appeared when Harold Godwin bought it. The new circular drive and retaining wall are prominent features. In the fence to the right of the entrance is a platform for getting on and off carriages. In the background are the boxwood-edged parterre garden and the roof of Bryant's garden toolshed. (NC.)

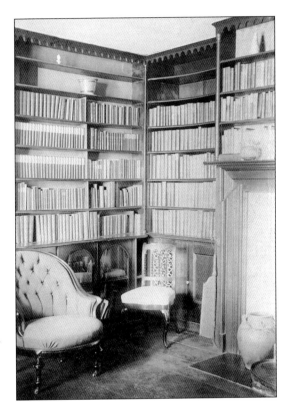

The only known interior photographs of the house during this period illustrate a corner of Bryant's study. The bookshelves, trim, mantle, and stove still appear as they did in the poet's day. (Right, Bryant Library Local History Collection, Roslyn, New York; below, NC.)

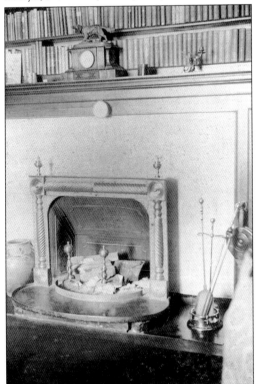

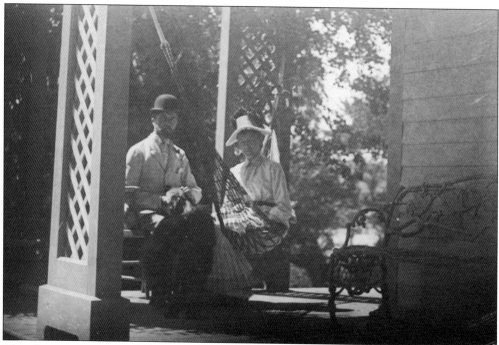

This photograph captures Herbert Satterlee (left) and Elizabeth Marquand Godwin sitting on the porch of Cedarmere in the 1890s. The hooks for the hammock are still on the columns today. To the right is Bryant's rustic-style cast-iron bench. (NC.)

Fanny Paddock and ? Clarke pose with Browning the dog in this photograph taken on the west side of Cedarmere in July 1886. Whether they were friends of the Godwins' or tenants is unknown. (NC.)

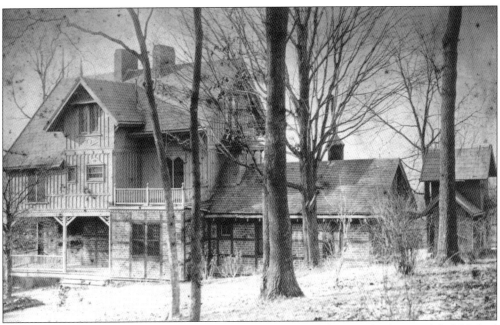

Harold Godwin also owned the Jerusha Dewey Cottage, which he completely remodeled. He had the original building jacked up and a new brick and frame ground floor and kitchen constructed beneath it, as seen above. The cottage eventually was owned by Childs Frick and his family, who lived there during World War II. The photograph below shows it a few years after the war's end. The exterior of the building has recently been restored to its early-20th-century appearance by the Gerry Charitable Trust in cooperation with the Roslyn Landmark Society. (Above, Roslyn Landmark Society; below, Library of Congress.)

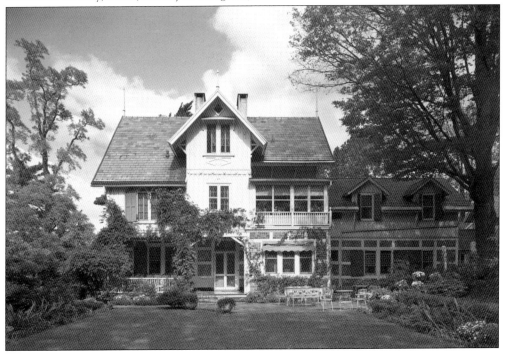

Harold Godwin did not continue growing crops on Bryant's upland farm (above). An avid golfer, he had a private nine-hole golf course of his own design placed there instead. In 1899, he sold the property to politician and publisher Lloyd Bryce, who had this mansion designed by Ogden Codman built on the site. Bryce's heirs sold it to the family of Childs Frick in 1917. It is now the Nassau County Museum of Art. (Above, AC; below, Roslyn Landmark Society.)

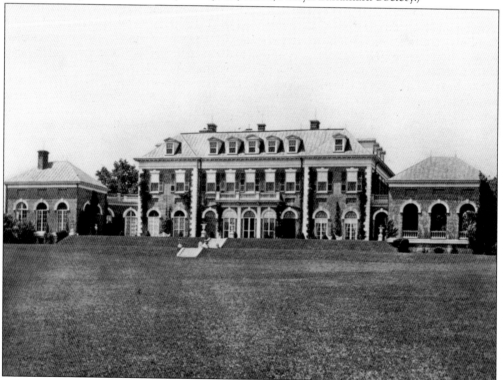

Five

FIRE AND RECONSTRUCTION

In 1902, Cedarmere was rented by Harold Godwin to Long Island yachtsman William Butler Duncan and his family, while the Godwins lived in Goldenrod. On November 15, when the Duncans were away, a spark from a faulty chimney in the laundry ignited a fire in the kitchen wing. It soon engulfed the entire wing and spread to the main part of the house, traveling through a space between the two roofs on the building and moving down toward the first floor.

The fire was discovered at 1:30 p.m. and reported to the Roslyn Rescue Fire Company. Eventually, companies from five communities in the area responded to the blaze, along with many local residents who were alerted by the tolling bell of the Roslyn clock tower. Tremendous effort was put forth by all. The 12 men working the Roslyn Rescue hand pump actually broke the machine's handles in their fight to quench the blaze, and two ponds north of the house were drained in the attempt to stop the spreading fire. Harold Godwin, aware of the valuable artwork, furniture, and books in the house, was able to direct local residents in rescuing many of the items from the flames. One Roslyn businessman, John S. Hicks, even managed to remove Richard Kirk's original delft tiles from the library's fireplace. The fire was not finally put out until dark. When the smoke cleared, only the parlor, library, and first-floor hallway had survived, along with the front and west facades of the house.

Harold Godwin, although devastated by the fire, was determined to rebuild Cedarmere. He assured readers of the *Roslyn News* on January 3, 1903, that "every effort [would] be made to have the house rebuilt in its old shape." Godwin did most of the design himself, hiring Roslyn contractor Lewis H. West to do the building. Conscious of the dangers of fire, Godwin had the house constructed with a slate roof and stucco siding instead of wood. His most significant change was the addition of a great room on the north side of the ground floor.

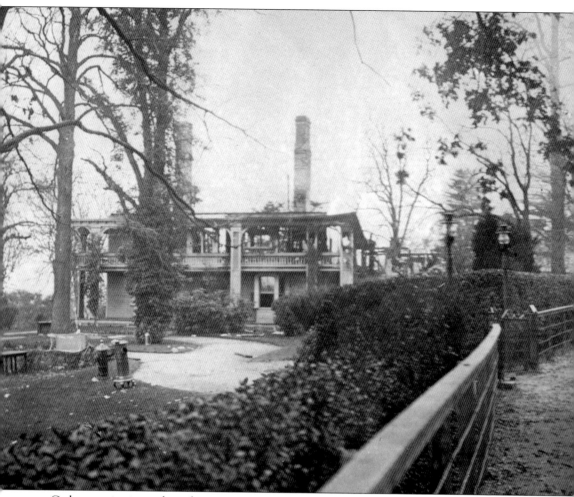

Cedarmere is pictured on the morning of November 16, 1902. The destruction of the previous day's fire is painfully obvious. The entire kitchen wing and upper floors of the house are gone; however, much of the front facade survived due to the heroic efforts of the local fire companies. Even Bryant's large rhododendron outside the entrance was saved. Furniture rescued from the house by helpful townspeople sits on the lawn. Beneath the large vine-covered tree is a lone fire extinguisher, which was of no use against the conflagration. (NC.)

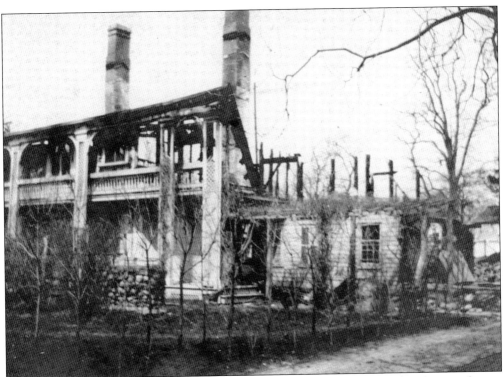

The fire started in the laundry of the kitchen wing (right) and quickly spread to the main house. It traveled through a gap between the house's two roofs—when the gambrel roof was added to Cedarmere, it was built about 18 inches above the previous roof. Once the fire got into that space, fire hoses were not able to reach the flames as they burned downward. (NC.)

The kitchen wing and back of the house were also photographed the morning after the fire, when the ruins were still smoldering. The shadows of the main house's two roofs are faintly visible near the top of the right-hand chimney. (NC.)

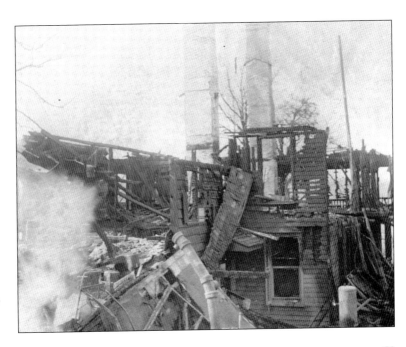

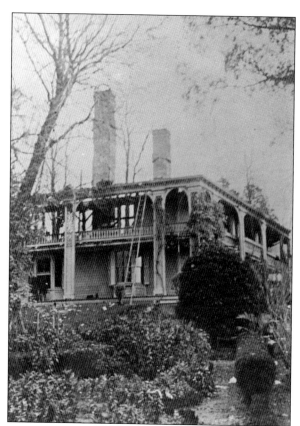

The fire spread downward from the upper floors of the main house. It was under control before it did much damage to the west side of the first floor, seen in these two photographs. This meant that the two most historically significant rooms in the house, Bryant's parlor (front corner) and study (rear corner), were largely intact. (Left, NCPA; below, NC.)

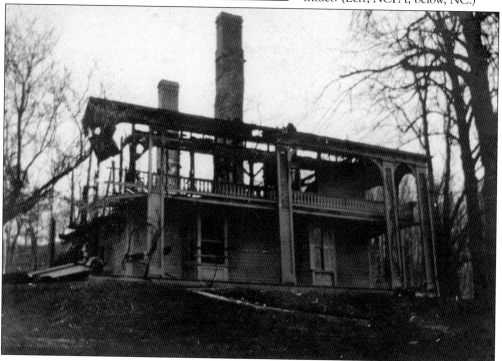

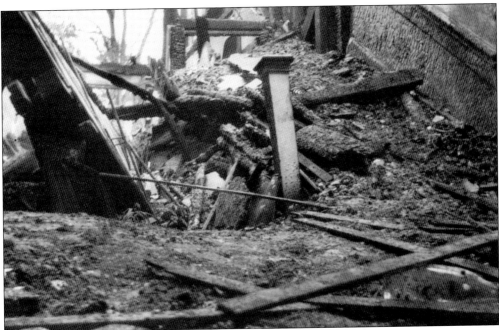

The destruction to Cedarmere's upper floors is captured in this photograph of the second-floor stair landing. Harold Godwin copied the original newel post in the foreground when rebuilding the stairway. (NC.)

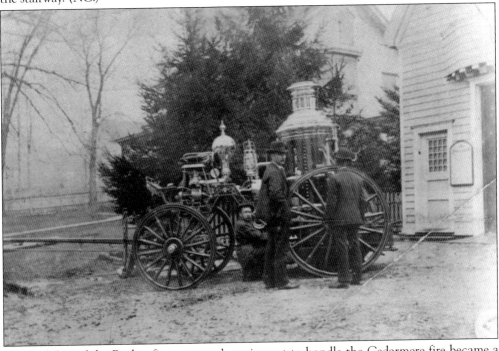

The inability of the Roslyn fire company's equipment to handle the Cedarmere fire became a concern to at least one Roslyn resident. In 1901, Clarence Mackay moved into his newly built 50-room mansion Harbor Hill, located south of Roslyn village. After Cedarmere burned, he donated this new Silsby steam pumper to the Roslyn Rescue fire company. (Roslyn Landmark Society.)

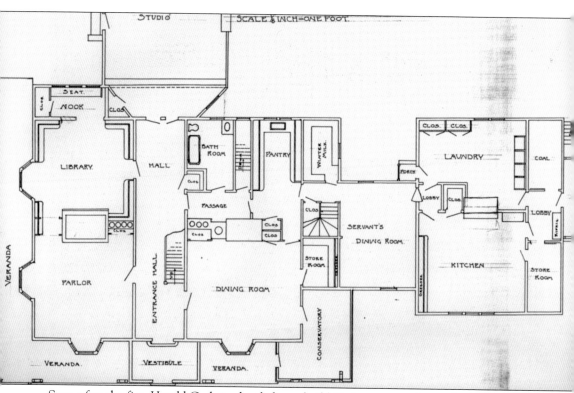

Soon after the fire, Harold Godwin decided to rebuild Cedarmere much as it had been. He did most of the designing himself. As seen in this 1903 plan of the ground floor, Godwin made few changes to the layout of the main part of the house. His alterations included modifying the servants' wing, shortening the kitchen and laundry, and eliminating the carriageway and pear tower. (NC.)

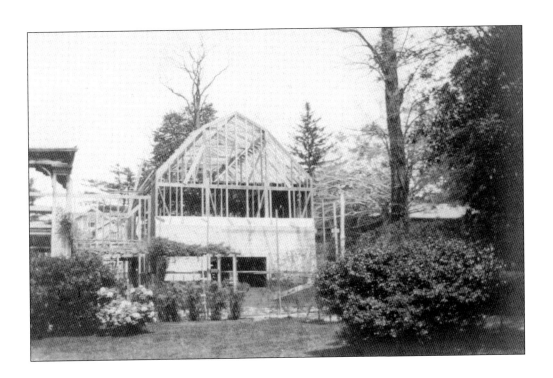

Godwin began reconstruction of the house in the spring of 1903 using local contractor Lewis West. Above, the new kitchen and servants' quarters wing begins to take shape. The gambrel roofline was designed to be reminiscent of the roof of the pear tower. Below, the house starts to reach completion. As much as possible of the original latticework columns and porch were preserved. (Both, NC.)

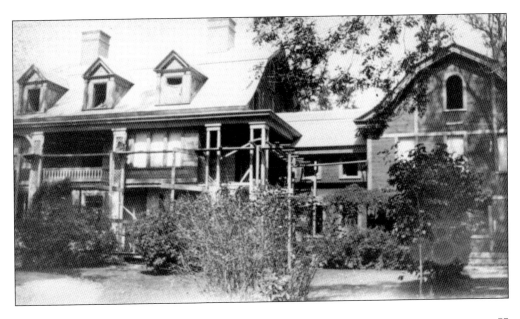

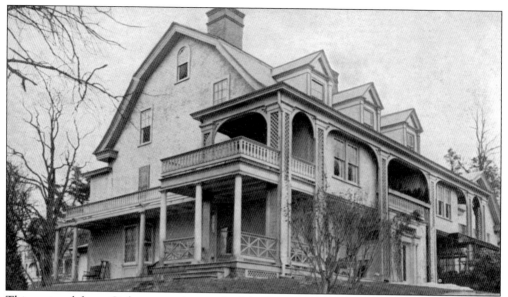

This postcard shows Cedarmere as it was rebuilt by Harold Godwin. Its basic appearance mirrored Bryant's house. The most significant change Godwin made was to cover the walls with stucco and give the house a slate roof to make the building more fire-resistant. (AC.)

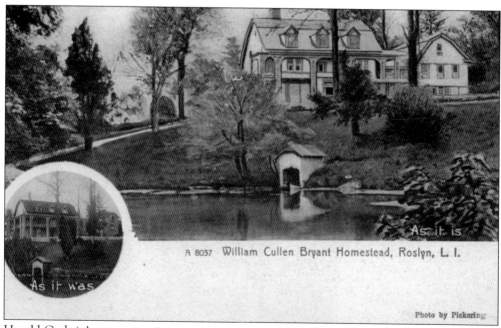

A 8037 William Cullen Bryant Homestead, Roslyn, L. I.

As it is

As it was

Photo by Pickering

Harold Godwin's reconstruction was seen as a conscious effort at historic preservation. Local businesses even sold these postcards of Cedarmere comparing "As it was" with "As it is." (AC.)

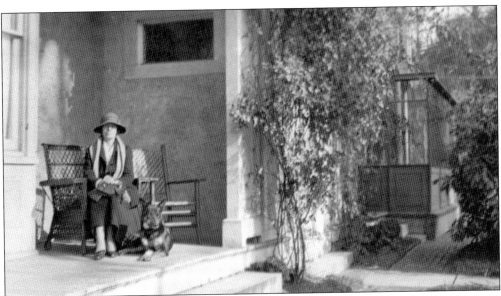

Although Godwin sought to preserve the basic appearance of Bryant's Cedarmere, he did make several changes in the building. One was adding a vestibule to the front entry. It projected out to the front of the porch, as seen in this photograph of Elizabeth Love Godwin with one of the family's German shepherds. The addition had a Greek Revival style doorway, seen on the right in this October 1904 photograph, which is labeled "Gabla." Bryant's original Dutch door with an oval window is preserved inside the vestibule. (Both, NC.)

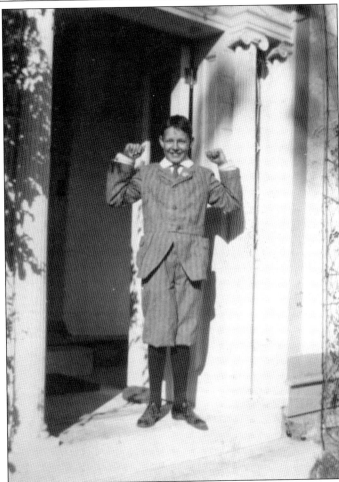

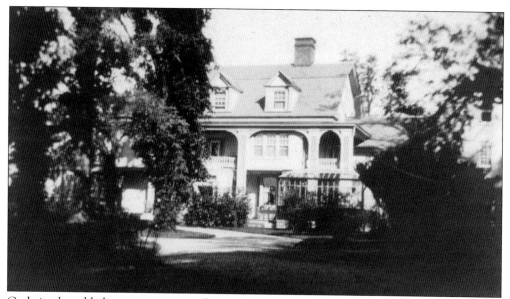

Godwin also added a conservatory to the southeast corner of the house, to the right in this 1905 photograph. This metal and glass structure was prefabricated in France and shipped over in pieces; when it was repainted for Cedarmere's opening in 1994, Roman numerals indicating how the pieces were to be assembled were visible on the lower panels. The conservatory, which connected to the dining room, was not a greenhouse to raise plants but a retreat where the Godwins could surround themselves with greenery in the colder weather. It contained a nonfunctioning antique fountain and a heating system for the winter. (Both, NC.)

Godwin's biggest change to the layout of the house was the addition of a great room to its north side at the end of the first floor hallway. It had a plain stucco exterior designed to blend with the rest of the house. In the foreground of this 1919 photograph are the family's doghouse and a southern magnolia dating to Bryant's day. To the left is the house where Harold Godwin's sister Fanny and her husband, Alfred White, lived. (NC.)

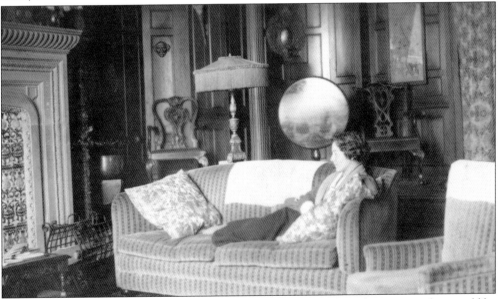

The great room, which the family called the studio, was designed as a living room that would be less formal than the parlor at the front of the house. Here, Elizabeth Love Godwin is relaxing on one of the couches. The massive sandstone hearth was finished with rows of Hispano-Moresque tiles. Family tradition holds that the oak paneling in the room and the curved doors in each corner were rescued from a New York townhouse and reused here. Not seen is the room's chandelier, which came from Elizabeth Marquand Godwin's father's mansion in Manhattan. (NC.)

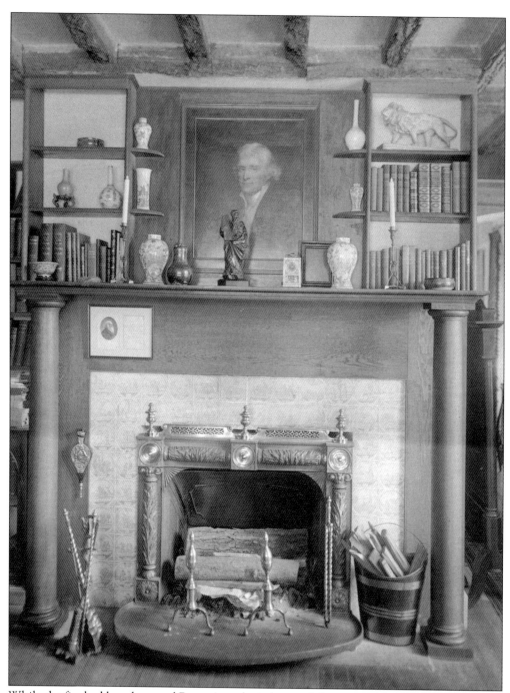

While the fire had largely spared Bryant's study, it damaged the upper part of the room. Godwin replaced the ceiling with rustic oak beams and totally redesigned the mantle, as seen in this 1904 photograph. To its right, he opened a passage to the parlor. Bryant's Franklin stove was retained, and two rows of the original delft tiles were reinstalled. The portrait above the mantle is of Thomas Jefferson, and a framed print of Bryant is hanging on the surround. (NC.)

Six

THE HAROLD GODWIN YEARS, 1903–1931

After rebuilding Cedarmere, Harold Godwin made it his family home. He lived there with his wife, Elizabeth Marquand Godwin, and their children Frederick Marquand Godwin, known to the family as "Leggety" or "Legs"; Elizabeth Love Godwin, known as "Lovey"; and Frances Bryant Godwin, called "Tiny."

The family, particularly the children, had an active social life. The women were all accomplished riders and took part in the activities of the Meadowbrook Hunt and other clubs. The girls enjoyed having cousins and friends visit, as did Frederick when he was home from St. Paul's prep school and later Princeton.

Harold was less outgoing than his wife and children, preferring golf and watercolor painting to attending parties. He enjoyed traveling and visiting the family's summer home in Lenox, Massachusetts, and their winter home in Aiken, South Carolina.

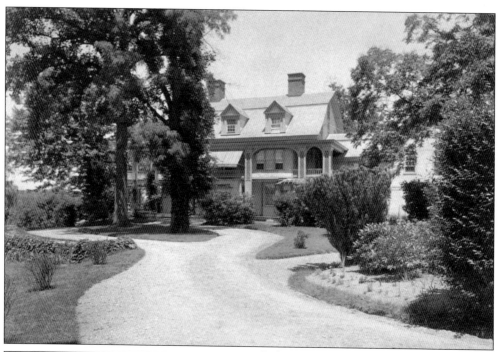

Cedarmere is pictured as it appeared when Harold Godwin and his family lived there. It was a spacious, comfortable house that the Godwin children and their friends kept full of life. As in Bryant's day, the first floor of the main house consisted of the parlor, study, dining room, and butler's pantry. Harold and Elizabeth Godwin's bedrooms and a guest room were on the second floor, and the children's rooms and another guest room on the third floor. The servants' wing contained the kitchen, laundry, servant dining room, linen room, and six maids' bedrooms. Each wing had an attic. (NC.)

One of many houseguests stands on the lawn near the conservatory. Behind her is the decorative pergola Harold Godwin added in front of the kitchen wing in 1903. A replica of the pergola was constructed as an Eagle Scout project in 2009. (NC.)

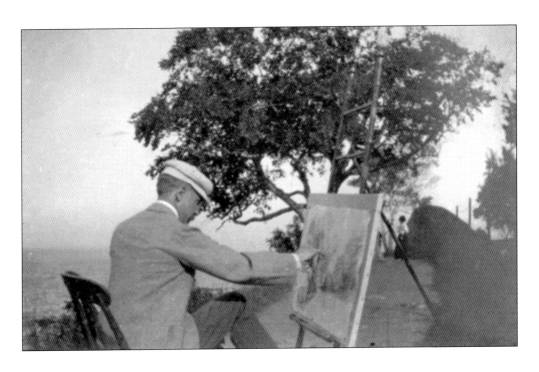

Each of the Godwins enjoyed different pastimes. Harold spent his free time playing tennis and golf and was an enthusiastic sculptor and watercolor artist. The photograph above shows him at work on a painting while vacationing in Europe. A number of his European scenes are incorporated into the frieze around the Cedarmere dining room. Below is one of his paintings of Cedarmere's sunken garden. (Both, NC.)

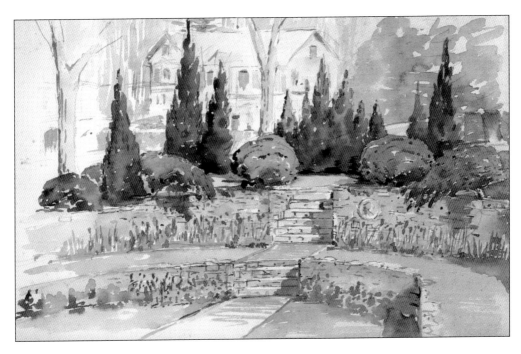

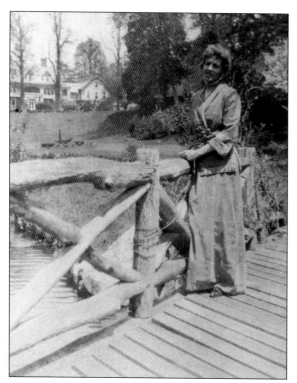

Elizabeth Marquand Godwin, seen here on the Cedarmere bridge around 1910, was active in community affairs. She was a longtime trustee of the Bryant Library Association and founded the Roslyn Visiting Nurse Association. She was also an accomplished horsewoman, a talent she passed along to her daughters. Below, she is driving an East Williston cart hitched to Birdie in front of Cedarmere in January 1907. (Both, NC.)

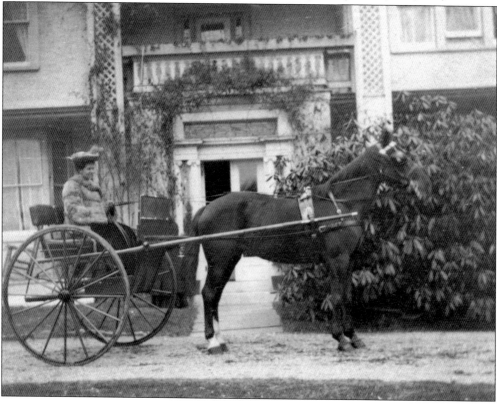

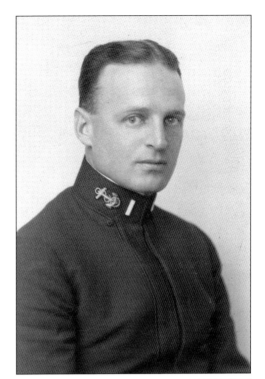

Frederick Godwin followed in his father's footsteps and attended Princeton University. After service in the Navy during World War I, he became a successful architect and moved to Katonah, New York. In 1919, Frederick designed the War Memorial building in Roslyn, pictured below around 1940. It is now the home of the Bryant Library. (Right, NC; below, Roslyn Landmark Society.)

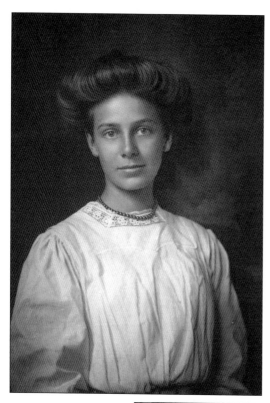

Elizabeth Love Godwin was the elder daughter of the family. Lovey, as she was known, was an active member of the Godwins' social set as a young lady. She traveled to Europe, rode in horse shows, visited friends and relatives in New York and Newport, spent time at the family's summer home in Lenox, Massachusetts, and entertained at Cedarmere. However, she never married, and spent her life at Cedarmere caring for her mother and sister and overseeing the estate. Tellingly, the photograph below is the only one in the family albums where she is laughing. (Both, NC.)

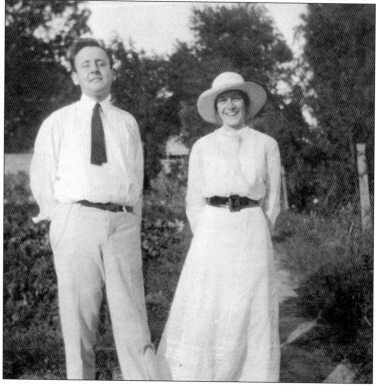

Frances B. Godwin, like her father, was a talented artist and sculptor. She began studying sculpture in her teenage years and continued for the rest of her life, specializing in animal studies. Her best-known work, *Mare and Foal*, is in the permanent collection of Brookgreen Gardens in Murrells Inlet, South Carolina. Frances also did portrait sculpture. She modeled a bas-relief of William Cullen Bryant, which hangs in the Bryant Library, and produced the delightful figure of the Cedarmere caretakers' daughter Eleanore Gschwind, seen below. Eleanore Gschwind Tooker and her family later gave the statue to the Cedarmere museum. (Right, NC; below, AC.)

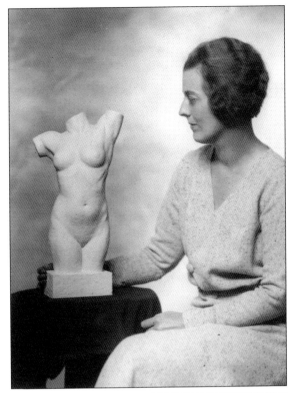

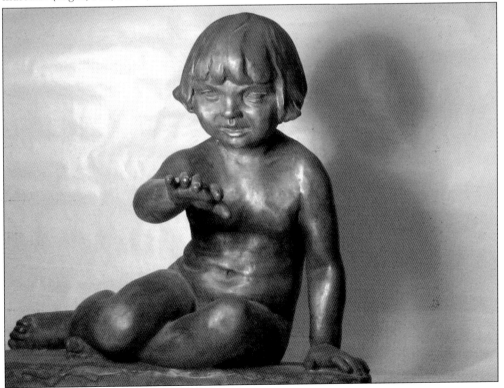

Harold Godwin constructed this building as a stable and barn in the early 1900s, probably after Bryant's barns across the street burned down. It was later used as the family garage, with living quarters for chauffeur (later estate caretaker) John R. Gschwind and his family on the second floor. It is shown here around 1950. Below, John's wife, Alice, is seen in her waders, holding a catch in front of the greenhouse on the south side of the garage. Their daughter Eleanore and her husband, John Tooker, later became the Cedarmere caretakers themselves. (Above, NC; below, Bradford Tooker.)

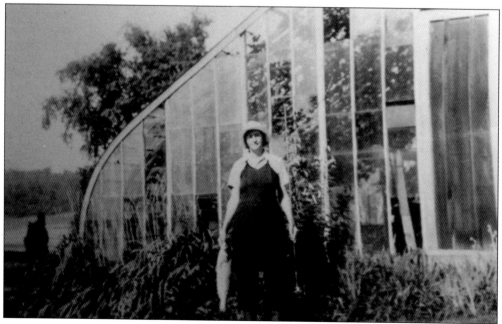

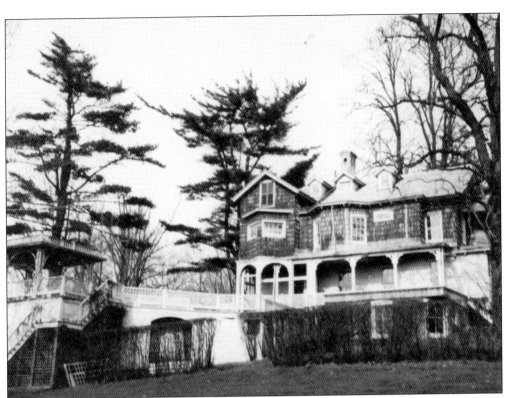

Harold Godwin's sister Fanny and her husband, Alfred White, lived in this house just north of Cedarmere, which stood to the right of this view. William Cullen Bryant had constructed it as a home for his estate manager, George Cline, and over the years it was greatly remodeled and enlarged. The attached gazebo is its most unusual feature; it provided a view of the harbor and may have overlooked an early tennis court. At right, Fanny White (right) and her sister Nora pay a visit to Cedarmere in Fanny's car in 1907. Fanny was first woman driver in Roslyn. (Both, NC.)

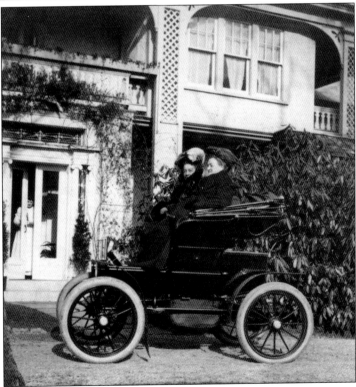

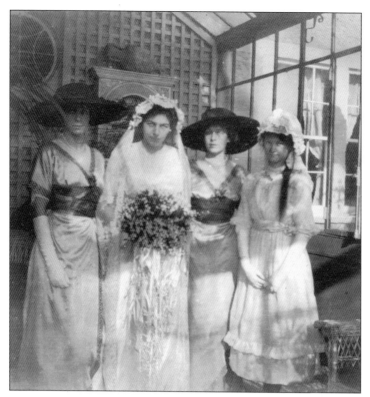

In December 1911, the Cedarmere studio was the site of the wedding of Harold Godwin's niece Nathalie de Castro to Rutherfurd Stuyvesant Pierrepont. It was a quiet wedding owing to the death of the groom's father a month before. At left, Nathalie poses in the conservatory with Elizabeth Love Godwin (left), maid of honor Frances B. Godwin, and bridesmaid Elizabeth B. Moffat, a niece of the groom (right). Below is a photograph of Nathalie's first child, Mary, with her nursemaid at Cedarmere in April 1913. (Both, NC.)

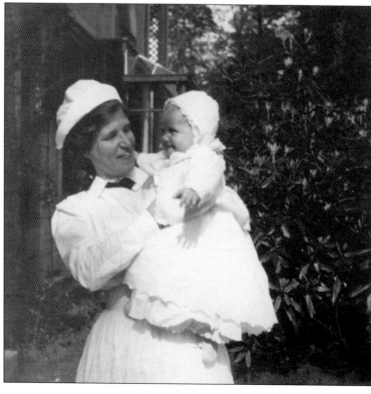

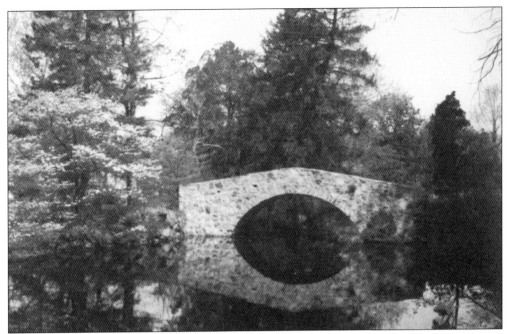

The rustic wooden bridge over the pond burned around 1916. It was replaced with this arched stone moon bridge soon after. The bridge is made from the same material as the walls of the sunken garden. A scene in the 1926 silent movie *The Quarterback* was supposedly filmed on the bridge. (NC.)

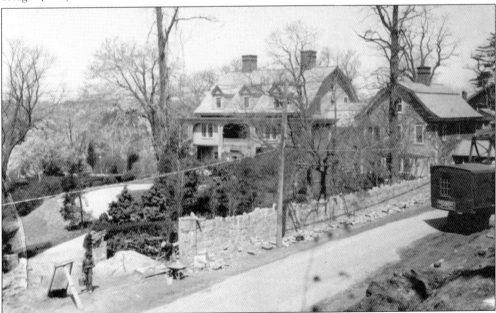

In the late 1920s, the section of Bryant Avenue near Cedarmere was widened. The steam shovel on the right was used for the project. To protect his privacy, Harold Godwin had the current stone and brick wall constructed from the White's house south to Cedarmere's main entrance. At the same time, he had a lower wall of the same design placed around the Bryant family plot in Roslyn Cemetery. (NC.)

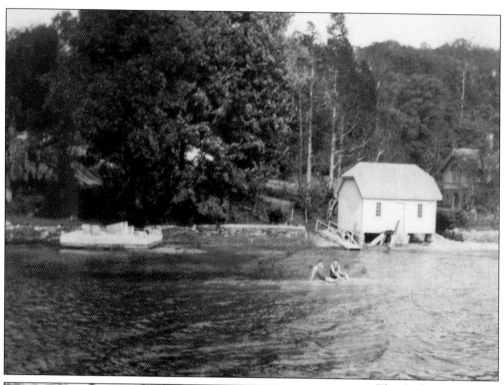

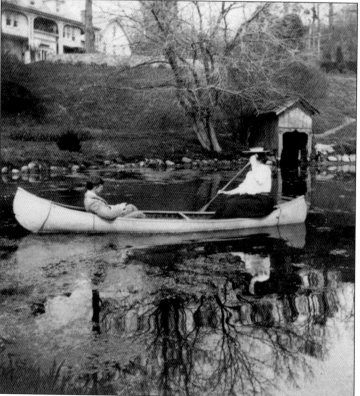

The Godwins and their friends enjoyed a variety of water sports at Cedarmere. Above, Gus Noel (left) and Frederick Godwin take a dip in front of the bathhouse in June 1912. The family later moored a houseboat in the harbor to use as a floating cabana. At left, Frederick enjoys a ride in the canoe on the Cedarmere pond in 1908. His companion is unidentified. (Both, NC.)

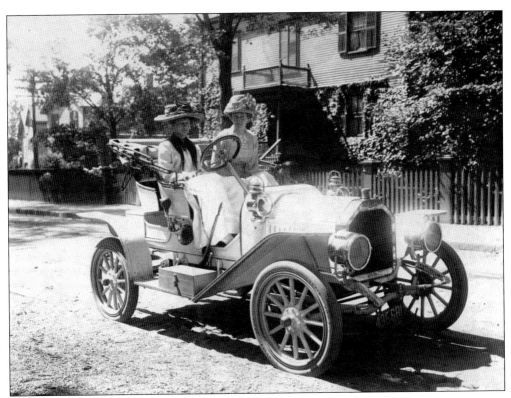

Fanny White was not the only woman driver in the family. Here, Elizabeth Love Godwin (left) and her sister Frances take a spin in the family's 1908 Buick. (NC.)

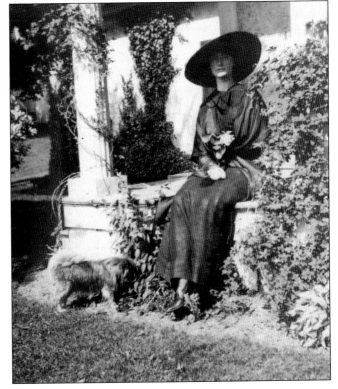

Most of the Godwins's visitors, like themselves, were in the *Social Register*. One, Linda Morgan of Newport, Rhode Island, who was a relative of Elizabeth Marquand Godwin, poses here on the west porch with Beppino the dog. (NC.)

This photograph captures a jolly group on the front porch of Cedarmere in 1912. From left to right are John Suydam, Bob Breese, Cecil St. George, Helen Rives, Elizabeth Marquand Godwin (in back), Mildred Rives, and Sara Whiting Rives (the girls' mother). Five years later, Frederick Godwin married Mildred Rives in the Cathedral of St. John the Divine in New York. (NC.)

The family loved dogs; they owned many, and Harold Godwin even raised German shepherds at one point. Frederick Godwin is seen here in 1912 with three of the family pets; from left to right are Beppo, Possum, and Stellina. (NC.)

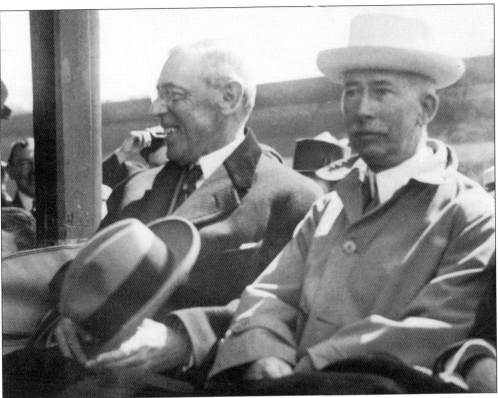

On June 24, 1915, Pres. Woodrow Wilson paid a visit to Roslyn to confer with Col. E.M. House (right), his unofficial envoy to Europe. While in town, Wilson also visited Harold Godwin at Cedarmere. Wilson and Godwin had been classmates at Princeton, where the future president counted Harold as one of his three closest friends. (AC.)

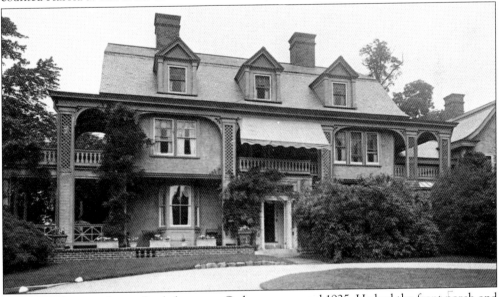

Harold Godwin made one final change to Cedarmere around 1925. He had the front porch and west porch extended and redone in brick. (NCPA.)

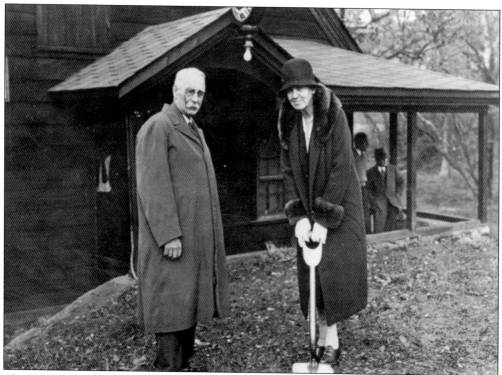

The Godwins continued their support of civic activities in Roslyn while they lived in town. Here, they take part in the ground breaking for a memorial in what is now Gerry Park. Behind them is the re-created paper mill building Harold had constructed in 1915 as one of his historic preservation projects. The family also donated many trees from Cedarmere to the park. (NC, original photograph by the *Roslyn News*.)

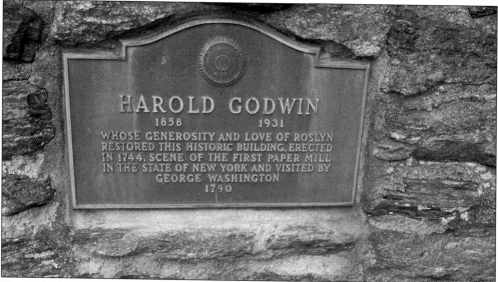

Harold Godwin died suddenly of a heart attack at Cedarmere on May 8, 1931, after returning from a trip to New York. His loss was deeply mourned by his family and staff and by the Roslyn community. He is commemorated by this plaque in front of the paper mill in Gerry Park. (AC.)

Seven

THE MILL

There has been a mill at Cedarmere since Richard Kirk constructed a water mill on the property in the mid-18th century. To power it, he connected two ponds into the single figure-eight pond presently on the site. Kirk's mill was used at different times as a fulling mill (to treat woolen cloth), a paper mill, and a cabinet factory. After William Cullen Bryant purchased Cedarmere, the mill was rented to a man who cut glass.

The original mill burned in 1849, and Bryant had it replaced with the current mill building in 1862. This highly ornamental Gothic Revival mill and summer cottage, which is probably unique in American mill architecture, is believed to have been constructed as a companion to the Jerusha Dewey Cottage. It was almost certainly designed by Frederick S. Copley, the architect of the Dewey Cottage.

The main floor of the mill was used as a summer cottage, and the mill works were housed on the lower level of the building. The difference in elevation between the pond and the harbor provided the mill machinery with plenty of power. This mill, unlike the previous one, was not constructed as a commercial enterprise but rather as a power train for machinery such as lathes and grindstones. The mill was also used to pump drinking water from an intake pipe in the pond to a reservoir on the hill east of Montrose, which provided water for both that house and Cedarmere.

The mill has undergone only a few changes since its construction. It was originally powered by an overshot wheel, which was replaced in 1888 by a turbine drive. Around 1930, the main floor of the building was converted into a sculpting studio for Bryant's great-granddaughter Frances Bryant Godwin. A skylight was put into the roof to provide more light, and a brick kiln was constructed just north of the building to fire clay. The mill building was recently restored through the generosity of the Gerry Charitable Trust, working in cooperation with the Roslyn Landmark Society.

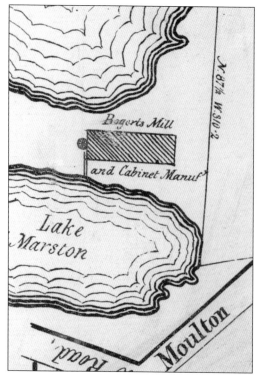

This early drawing of the original mill layout is from around 1830, when it was used by a cabinetmaker. "Lake Marston" is what Joseph Moulton called the Cedarmere pond. The mill burned in 1849 and was replaced in 1862 by the ornate Gothic Revival mill and summer cottage shown below in an 1878 print from *Scribner's Monthly*. The boxlike object to the left of the mill is a penstock that directed water from the pond onto the overshot waterwheel below. (Left, NC; below, AC.)

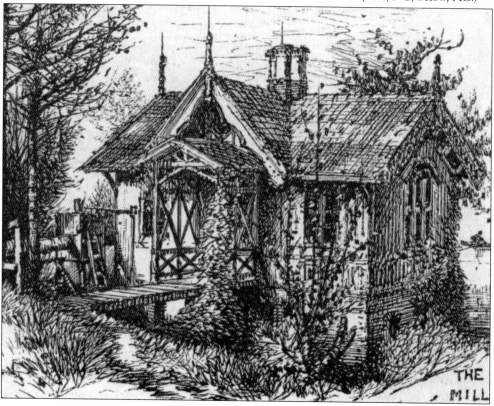

THE MILL

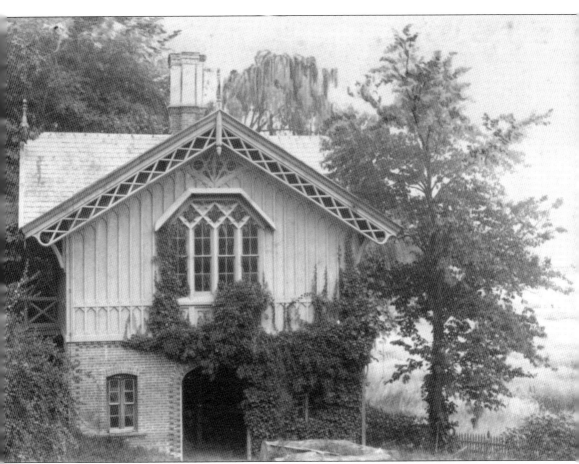

This is an early-20th-century view of the Gothic Revival mill's north facade. The diamond pane windows contained Bryant's initials etched in Gothic letters. The lower portion of the structure, constructed in brick, housed the mill works. The summerhouse above was painted light ochre. The fencing on the right marks the property's boundary along Hempstead Harbor. (NC.)

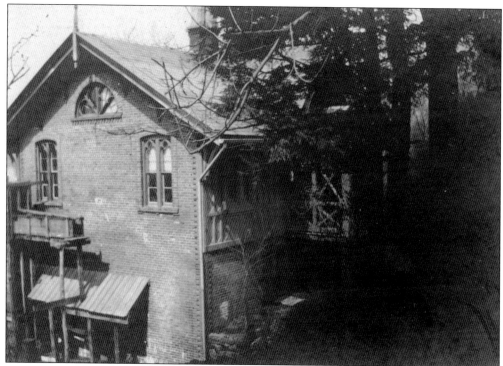

The south facade of the mill is seen here around 1900, after the waterwheel was replaced by a turbine drive housed under the pitched wooden roof. Since this wall received the vibration from the mill's drive train, it was constructed entirely of brick. The purpose of the boxlike structure at the left is unknown; it may have been part of Harold Godwin's plan to use the mill to power a dredge along the shore. (NC.)

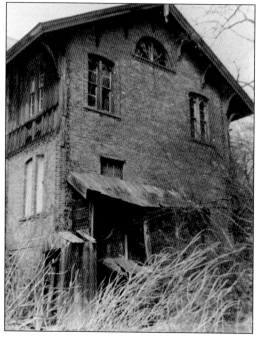

The south side of the mill is seen in this 1975 photograph showing the remains of the turbine drive and shelter. The small shed to its left is an outhouse. (NC.)

The mill ceased operation in the early 1900s. In 1929, it was converted into a sculpting studio for Frances Godwin. This brick kiln was constructed just north of the mill at that time. The photograph below, taken in 1975, shows the skylight that was installed on the west roof of the mill for the studio. (Both, NC.)

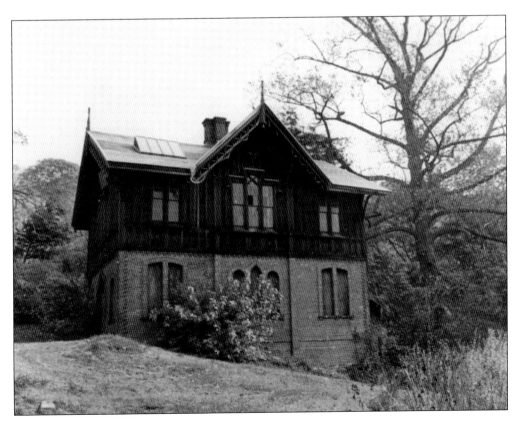

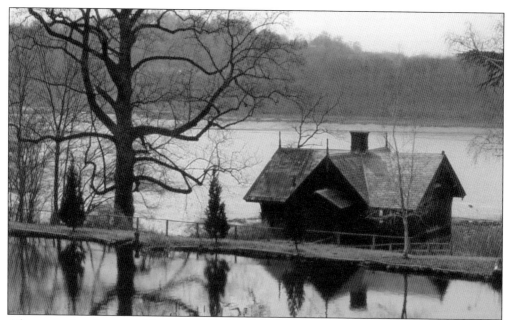

After extensive clearing of the grounds in 1994 and 1995 and cleaning of the mill the following year, the building was opened to the public. This photograph shows the large drop between the pond and the harbor that allowed the mill to operate. The huge tulip poplar to the left of the mill is one of the few trees on the property remaining from Bryant's time. (AC.)

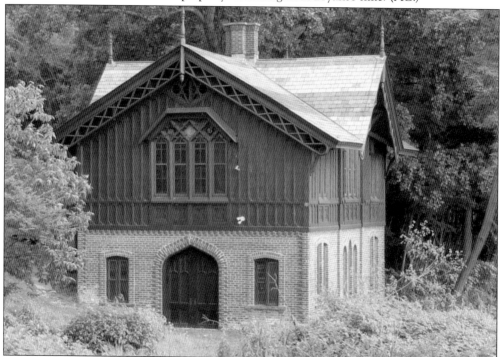

The exterior of the mill was recently restored by the Gerry Charitable Trust in cooperation with the Roslyn Landmark Society. Damaged windows were replaced, the basement doors rebuilt, and the upper level woodwork repaired and given a dark oil stain. (AC.)

Eight

THE GARDENS

Just as the main estate evolved, so did Cedarmere's gardens. Bryant and the Godwins who came after him were avid horticulturalists, and the gardens and grounds reflected this interest.

The formal garden during the poet's lifetime was an English boxwood parterre forming a decorative geometric border around a variety of roses, annuals, and perennials. North of this parterre were additional linear beds. According to Bryant, it was his wife, Fanny, who was in charge of this part of the property. "When I am at work in the garden, I like to have Mrs. Bryant at my side," he wrote in 1850, "not on account of my ignorance of the proper method of putting seeds into the ground," but so he could be sure to place them in a spot she approved.

William Cullen Bryant, however, had a definite interest and was in the habit of recording the flowers still blooming on his birthday, November 3. The location of the parterre, protected by the harbor on the west and the hillside on the east, provided shelter for the garden and gave it a somewhat longer season for blooming. Bryant maintained a grapery and an elaborate series of greenhouses and cold frames just below the parterre. Varieties of fruit trees were also planted there, and vegetables were provided for the family from plantings just north of the mill.

During the early Godwin years, the linear flower beds were replaced by a tennis court and a metal gazebo. The most significant change took place in 1916, when Harold Godwin had the tennis court replaced by an Italianate sunken garden of his own design. A low stone wall bordered by perennials ringed a central grass lawn with a fountain at one end. On the wall facing it, Godwin, a gifted sculptor, installed a bas-relief he had done of his illustrious grandfather.

The Cedarmere gardens were restored beginning in 1995. Photographic, archaeological, and archival evidence were used to recreate the parterre garden and to restore the stonework of the sunken garden.

This is the earliest known photograph of Bryant's parterre garden. Its geometric sections are surrounded by low boxwood hedges. Foxglove and balsamina can be made out in the closest triangular bed. The path from the house to the garden is in the foreground. (NC.)

To the back and north side of the parterre garden, Bryant had linear flower beds as well. One can be seen planted to the right of the parterre in this family photograph taken around 1900. (NC.)

As a good gardener should, Bryant kept track of his plantings. This 1870 list of autumnal blooms shows perennials, annuals, and roses. Some herbal plants, such as feverfew and lemon verbena, also appear. He mentions that no frost had occurred yet by October 19. (Bryant Library Local History Collection, Roslyn, New York.)

This small toolshed in the northwest corner of the garden provided convenient storage for garden implements. Designed by local carpenter Washington Losee in 1864, it was restored through the generosity of his descendant Thomas Losee Jr. In the 20th century, children of the caretakers used it as a playhouse. (AC.)

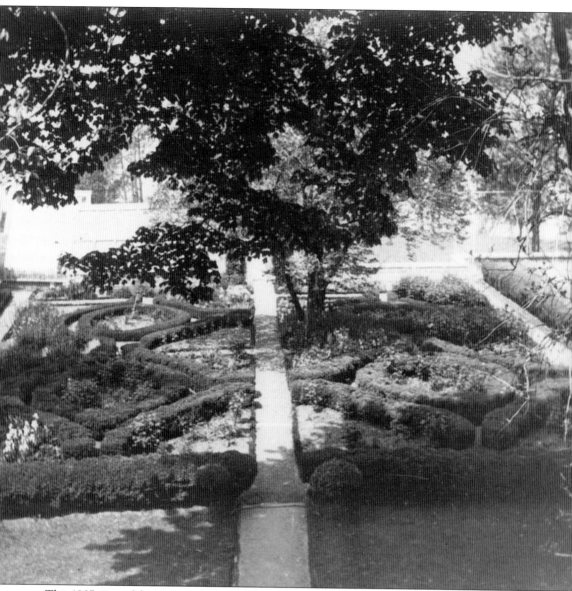

This 1907 view of the parterre from the balcony of Cedarmere was critical in restoring the gardens. It shows the four boxwood-enclosed squares created by central pathways crossing at right angles. Each square has an English boxwood circle surrounded by four triangular beds. The outer edges of these parterre beds were cut lower than the inside borders to allow for better viewing. A *Magnolia stellata* stands just right of center. Linear beds, edged by boxwood, were placed at the rear of the parterre, and behind them to the left are the greenhouses and grapery from Bryant's time. On the right is the tennis court, separated from the formal gardens by a boxwood hedge. (NC.)

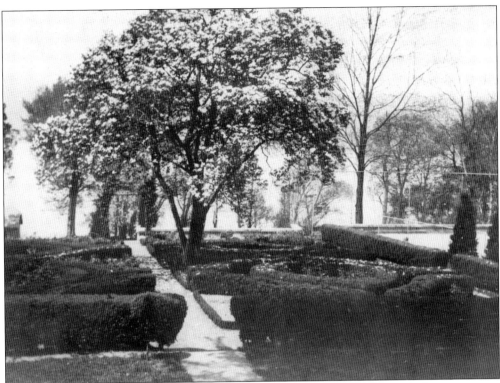

Around 1900, Harold Godwin replaced the linear beds north of the parterre with the tennis court seen at the right in this early-20th-century photograph. He also surrounded the parterre with a boxwood hedge at this time. Behind the tennis court's retaining wall stands a young pignut hickory tree, which has since grown to be the largest of its variety on Long Island. The tennis court, in turn, was replaced by a masonry-edged sunken garden of Godwin's design in 1916 (below). The toolshed is visible to the right of the fountain. (Both, NC.)

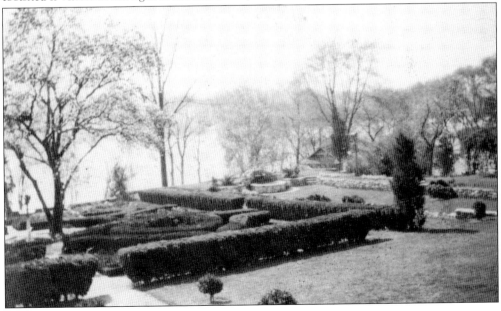

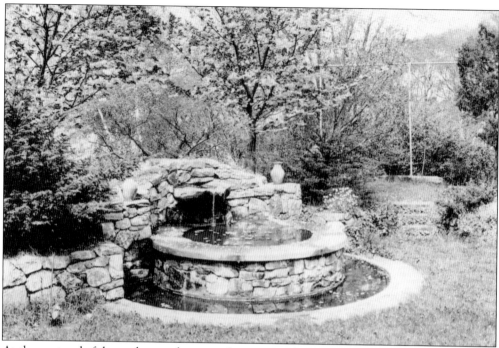

At the west end of the sunken garden was a fountain made of the same stone as the garden walls; family tradition states that it was rock produced while excavating for subways in Manhattan. The single stream of water was not recycled but flowed from the upper level to the lower basin and out a drain. Flowering dogwood and cherry trees can be seen in the background of this photograph taken in May 1924. (NC.)

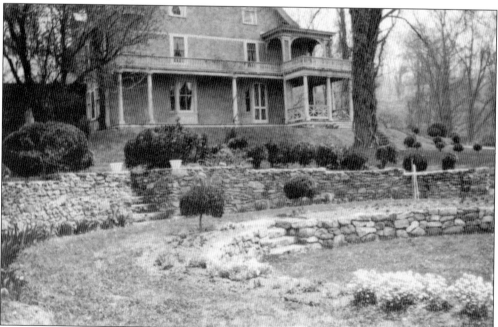

Opposite the fountain, the east end of the sunken garden was bordered by a second wall closer to the house. A set of steps at its center led down to the sunken garden itself. (NC.)

The sunken garden's east end, shown here shortly before Harold Godwin's death in 1931, had beds of irises hugging the curve of the outer wall and shrubs around the top. The porch and stairs seen beyond it were attached to Alfred and Fanny White's house behind Cedarmere.

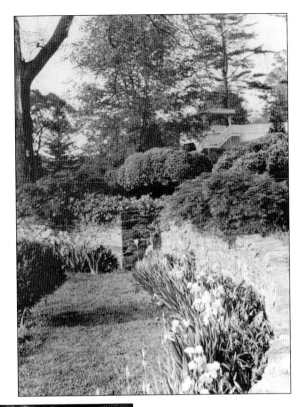

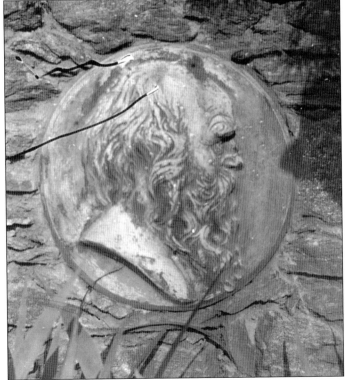

Harold Godwin placed a bas-relief of William Cullen Bryant, which he had sculpted, into the east wall of the sunken garden. Godwin had studied portrait sculpture with Augustus Saint-Gaudens, who praised his work. Unfortunately, the relief was stolen in 2011. (NC.)

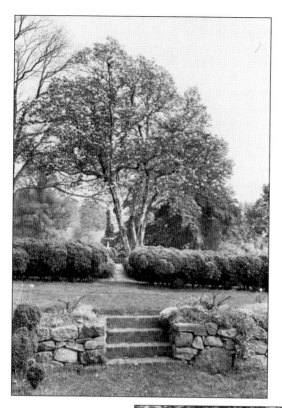

The grassy area between the sunken garden steps and the parterre was photographed in the late 1920s. The steps are approximately along the net line of the former tennis court. The boxwood has become quite mature at this point, as has the flowering magnolia tree. (NCPA.)

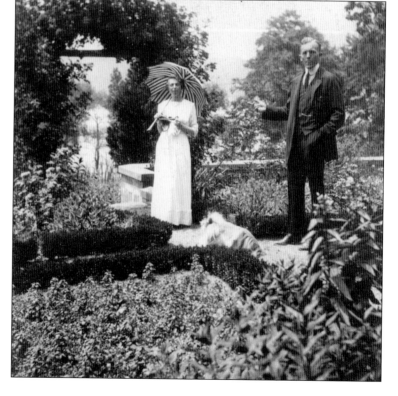

Nathalie de Castro Pierrepont and Hallam Tuck admire the blossoms in the parterre garden in June 1912. The archway behind Nathalie was formed with the heart-shaped trellis that had been above the front entrance to Cedarmere before the fire. (NC.)

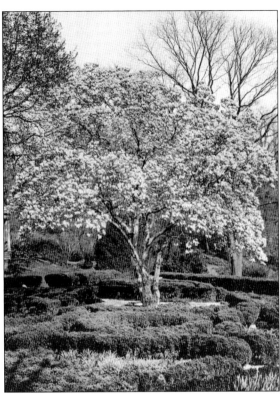

Both of these photographs, taken in 1930 (right) and 1929 (below), show a mature parterre garden. A prominent feature of both is the garden's *Magnolia stellata* with its creamy flowers. The outer border of boxwood that Harold Godwin added to the garden is clearly visible around the parterre. The photograph below shows Elizabeth Love Godwin with Molly, one of the family's many dogs. Behind them is the fountain and basin that Harold Godwin eventually installed at the center point of the parterre. The figure on the porch is likely Elizabeth's mother. (Both, NC.)

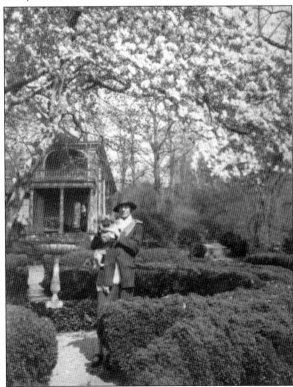

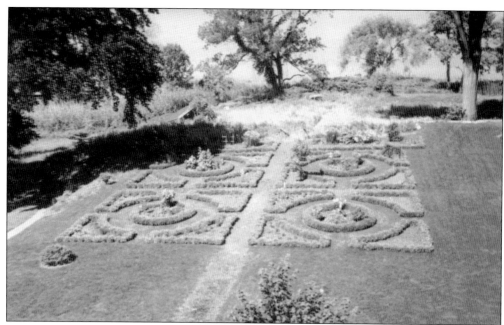

By the time preparation for Cedarmere's opening began in 1994, both of its flower gardens were seriously damaged and overgrown. All of the boxwood forming the parterre had been removed in the 1980s, and the area was covered with vines and weed trees. After these were removed, the area was seeded for grass, and the parterre was laid out based on family photographs. Surprisingly, the new grass grew greener where the flower beds were than where the paths had been, showing that the layout was correct. Cedarmere's neighbors Carol and Millard Prisant and the law firm of Koeppel, Martone & Leistman donated the 900 boxwood plants it took to recreate the garden in 1996 (above). In the sunken garden (below), half of the stonework had disappeared and needed to be replaced. Plantings in both gardens were sponsored by Koeppel, Martone & Leistman. (Both, AC.)

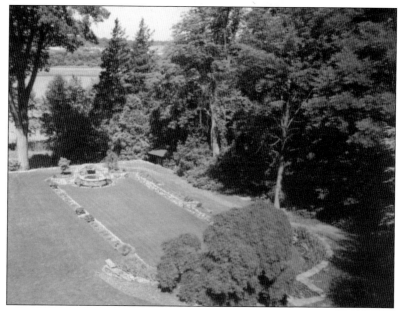

William Cullen Bryant built several structures to help maintain his gardens. The 1878 view from *Scribner's Monthly* above shows, from left to right, cold frames, a forcing shed, a toolshed, Bryant's grapery, and his greenhouse. Harold Godwin continued using these buildings, as seen in this photograph taken around 1915 from the porch of Cedarmere. (Above, AC; below, NC.)

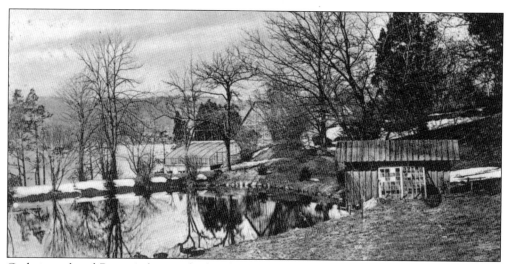

Godwin replaced Bryant's forcing shed with a greenhouse around the time he had Cedarmere rebuilt. It is seen to the left in this highly detailed 1906 postcard. The grapery is visible just beyond it. On the right side of the pond, two cold frame windows rest against the boathouse. (AC.)

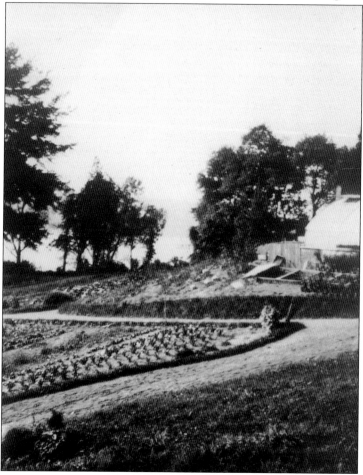

Cedarmere's vegetable gardens were planted west and south of the greenhouses and grapery. These beds, photographed around 1910, were between the mill and Harold Godwin's new greenhouse. Both Bryant and the Godwins cultivated vegetables here to supply their kitchen needs. The Godwins continued hiring men to farm this part of the property into the 1940s. (NC.)

Nine

THE CEDARMERE MUSEUM

Following Harold Godwin's death in 1931, his widow continued to live on the estate with their daughters and the family of caretakers John and Alice Gschwind. When Elizabeth died in 1951, her daughter Elizabeth purchased Cedarmere from the estate as her home. Soon thereafter, she sold Goldenrod and the property south of the bridge, leaving Cedarmere with the seven acres it has today. Her sister Frances, a sculptor, went further afield, with studios in Brooklyn, Lenox, and Gloucester, Massachusetts, and Charleston, South Carolina, as well as in the Cedarmere mill. Neither sister married.

Frances Bryant Godwin died in March 1975, leaving $100,000 to establish a fund for the upkeep of Cedarmere. Four months later, her sister Elizabeth followed her in death, giving Cedarmere all her Bryant-related material and Frances's fund to Nassau County to open the site to the public as a museum and memorial to William Cullen Bryant.

Restoration of the estate did not begin until early 1994 in preparation for the November bicentennial of Bryant's birth. Cedarmere's study was restored and refurnished, an orientation exhibit installed, and the site's badly overgrown grounds made usable. In the years that followed, the house's parlor, first-floor hallway, great room, and butler's pantry were also restored and the mill opened to the public. Outdoors, the parterre and sunken gardens were authentically re-created, the grounds were landscaped, and a program of planting donated fruit trees was begun. All of this was accomplished with the invaluable help of many volunteers. Descendants of the Bryant family were also supportive, providing information, funding, and items for display.

In addition to the guided tours of the house offered, Cedarmere has been the home to many programs that reflect the legacy of William Cullen Bryant and the Godwins, including poetry readings, concerts, lectures, holiday celebrations, watercolor painting and sculpting classes, garden tours, nature walks, Bryant birthday commemorations, and school programs. These activities and Cedarmere's picturesque location overlooking Hempstead Harbor have brought thousands to the site to appreciate its historical significance and enjoy the same natural beauty that delighted William Cullen Bryant 150 years ago.

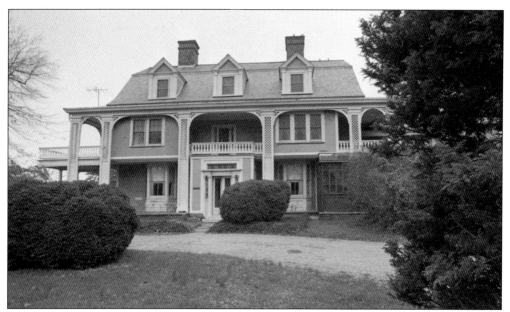

After Harold Godwin's death in 1931, ownership of Cedarmere—pictured here around 1970—passed to a family trust, and after his widow's death, daughter Elizabeth Love Godwin purchased the house from the trust and became sole owner. Elizabeth, seen below at Bryant's desk in the study in 1952, continued living in the house for the rest of her life. She was quite conscious of the historic significance of the estate and concerned with its future. Upon her death in 1975, she left the house to Nassau County to preserve as a museum. (Above, NCPA; below, *New York Herald-Tribune* Photograph Morgue Collection, Queens Borough Public Library, Long Island Division.)

Elizabeth's sister Frances B. Godwin eventually moved to Charleston, South Carolina, where she (center) and some of her sculptures are seen with her attorney Henry Gaud and his wife, also named Frances, in 1961. Frances Godwin, too, was concerned with Cedarmere's preservation and, in her will, left a trust fund of $100,000 to provide money for the estate's ongoing maintenance and restoration. (Evening Press Industries, Charleston, South Carolina.)

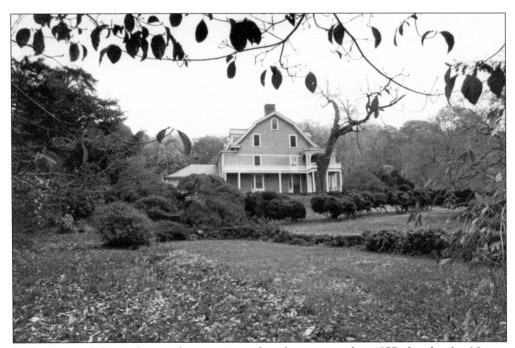

Cedarmere and the sunken garden are pictured as they appeared in 1977, shortly after Nassau County received Elizabeth Love Godwin's bequest. In the years that followed, much work would have to be done to get the house and grounds restored. (NC.)

After a long period of study, Cedarmere was officially opened to the public for Bryant's bicentennial in November 1994. Speakers at the formal dedication (above) include, from left to right, William Cullen Bryant II, Nassau County commissioner of parks John Kiernan, Maxwell Wheat, and deputy commissioner of parks Nicholas Dellisanti. Wheat, a leading Long Island poet, was named Nassau County's first poet laureate at Cedarmere in 2007. Below, William Cullen Bryant II, a collateral descendant of the poet who coedited Bryant's correspondence, delivers the keynote address. (Both, NC.)

Visitors view Bryant's study on opening day. The study (below) was the only room in the house historically furnished at that time. Its restoration was based on Bryant period images and an inventory of the house done after the poet's death. The books and many of the furnishings were original pieces that had been bequeathed by Elizabeth Love Godwin along with Cedarmere. (Above, NC; below, AC.)

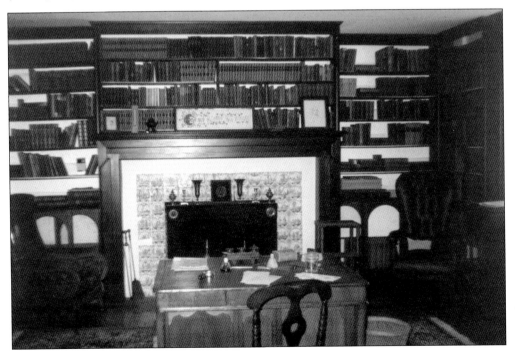

The next year, the first floor hallway and parlor were furnished. These rooms and the study were selected for restoration to Bryant's time because they had survived the fire basically intact. Original items belonging to William Cullen Bryant were displayed wherever possible; when such items were missing, similar furnishings were used. In the parlor, for instance, the sofa, chair, and ceramics belonged to the poet. Most of the woodwork dates to the original 1787 house. (Both, AC.)

Dozens of curators, carpenters, groundskeepers, electricians, signmakers, exhibit technicians, and other workers helped open Cedarmere in 1994. The four staff members who did the most—working full-time for seven months to get the site restored—are, from left to right, Gregg Hammond; Nassau County Parks Department supervisor of historic sites Harrison Hunt; volunteer Linda Fischer (now Hunt); and Daniel Kaplan. After the museum opened, the work continued, as additional parts of the house and grounds were refurbished. The most dedicated of the museum's many volunteers was Ray Kubeskie, seen on the right at a volunteer recognition lunch. His skill at repairing anything, from a doorknob to a plaster ceiling, is summed up on a plaque at Cedarmere placed in his memory: "His hands were gold." (Both, AC.)

The spirit of William Cullen Bryant is still very much evident at Cedarmere. The poet himself sometimes makes an appearance in the form of local actor Frank Hendricks (left), who has delivered many poetry readings at the house. Bryant descendants, too, have visited the site and provided historical information and support for its programs. Below, Faith Goddard, Bryant's great-great-granddaughter, chats with then site director Harrison Hunt. (Both, AC.)

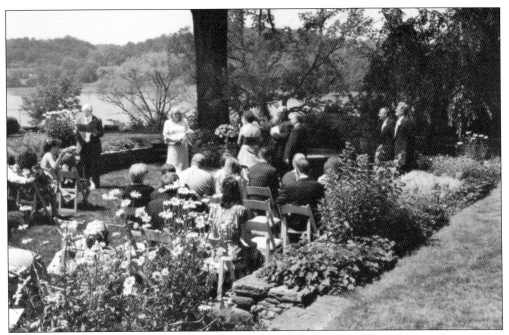

The Cedarmere house and gardens have become a popular location for weddings, christenings, memorial services, and birthday celebrations. Above is the authors' wedding in the sunken garden in 2008. Below, they are seen after the ceremony in front of the heirloom pear orchard they helped re-create. (Both, AC.)

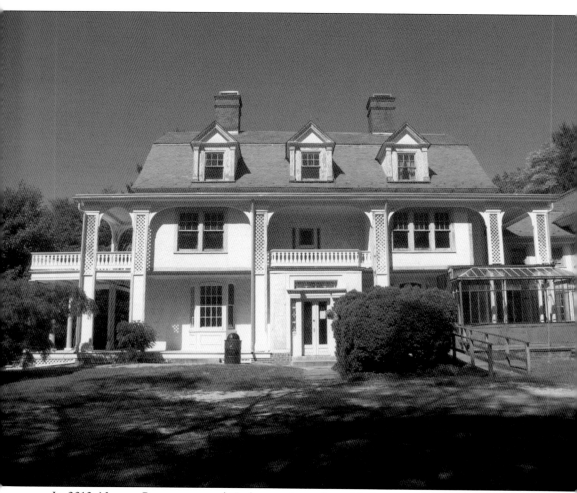

In 2010, Nassau County restored Cedarmere's porch and balcony to their early-20th-century appearance, utilizing a grant from the New York State Office of Historic Preservation. (AC.)

BIBLIOGRAPHY

Bennett, Diane Tarleton, and Linda Tarleton. *W.C. Bryant in Roslyn*. Roslyn, NY: Bryant Library, 1978.

Brown, Charles H. *William Cullen Bryant*. New York: Charles Scribner's Sons, 1971.

Bryant, William Cullen II, and Thomas Voss, eds. *The Letters of William Cullen Bryant*. Six vols. New York: Fordham University Press, 1975–1992.

Goddard, Conrad Godwin. *The Early History of Roslyn Harbor, Long Island*. Self-published, 1972.

Hunt, Harrison. "Cedarmere." *Roslyn Landmark Society Annual House Tour Guide*. Roslyn, NY: Roslyn Landmark Society, 2003.

Kroplick, Howard. *North Hempstead*. Charleston, SC: Arcadia Publishing, 2014.

Powers, Horatio N. "William Cullen Bryant." *Scribner's Monthly* 16 (August 1878): 479–495.

Russell, Ellen Fletcher, and Sargent Russell. *Roslyn*. Charleston, SC: Arcadia Publishing, 2009.

DISCOVER THOUSANDS OF LOCAL HISTORY BOOKS FEATURING MILLIONS OF VINTAGE IMAGES

Arcadia Publishing, the leading local history publisher in the United States, is committed to making history accessible and meaningful through publishing books that celebrate and preserve the heritage of America's people and places.

Find more books like this at
www.arcadiapublishing.com

Search for your hometown history, your old stomping grounds, and even your favorite sports team.

Consistent with our mission to preserve history on a local level, this book was printed in South Carolina on American-made paper and manufactured entirely in the United States. Products carrying the accredited Forest Stewardship Council (FSC) label are printed on 100 percent FSC-certified paper.

MADE IN THE USA